DANBY
Images of Sport

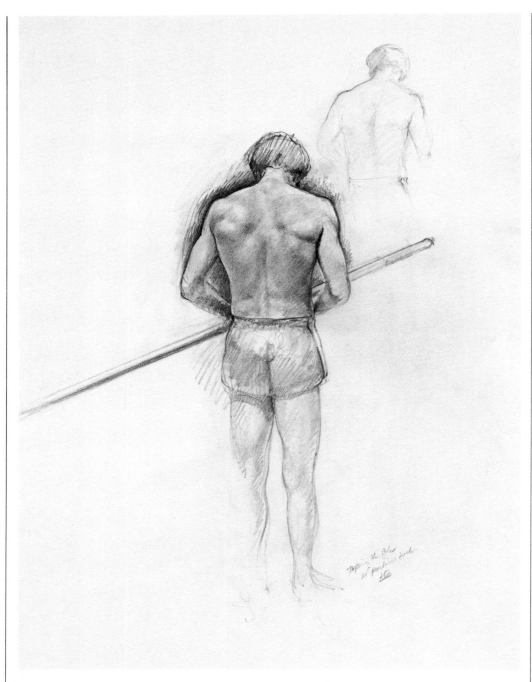

Taping the Pole , Pencil, 18 3/4" x 16", 1975 ,Private Collection.

DANBY
Images of Sport

by
Hubert de Santana

Published by
Amberley House Limited
Toronto

Distributed by
Macmillan of Canada, Toronto

"Every great art has interpreted its own time in terms of that time and no art can depict our own time without giving a large place to its athletics. We have seen how the Egyptians, with their wall carvings and their statues, have left a complete record of their daily life and doings . . . and this, with the great legacy left us by the Greeks, must surely show us a worthy field for the artist in depicting the sports and games which form so vital a part of the education of our boys and girls and a rallying point in our national life."
Robert Tait McKenzie

To one who approaches it from the east, through the passes of the scarped and barren Arcadian mountains, Olympia is an unforgettable sight. It lies in a fertile valley among green and flowered hills, its marble ruins scattered through groves of olive, cypress and pine. Beyond the blue meanders of the river Alpheus, the more distant hills appear opalescent in the vivid, crystalline air.

Down in the Olympic glade the atmosphere is spiced with the odours of pine, thyme and wildflowers. This is a sacred precinct, a shrine consecrated to Zeus since 1000 BC. But there is another reason why Olympia exerts a powerful fascination: it was the site of an extraordinary event which was held every four years without interruption for more than a thousand years — the Olympic Games.

There were other sports festivals in ancient Greece, in an age unprecedented for its celebration of athletic prowess. There were the Pythian Games at Delphi, held every four years; the Nemean Games at Argolis, and the Isthmian Games at Corinth, held every two years. Of the four major festivals, the Olympic Games were the most famous and the most important.

In Olympia today there are still signs and relics of the Games which began in 776 BC and were held regularly until at least 261 AD. In the ruined stadium one can see the grooved starting block on which runners lined up at the start of a race. It is wide enough for twenty men, each of whom was allowed four feet of lateral space. Time has felled the forest of statues erected at Olympia to commemorate the victories of champion athletes; and all that remains of the temples, gymnasium and other buildings are ruins, and a few fluted marble columns mottled with a golden patina acquired over the centuries. The Palaestra, or training area, is now a grassy meadow speckled with daisies.

It is a tranquil place, yet somehow it sends the mind spinning back across two millennia, so that it is not difficult to imagine the febrile excitement of the events which took place here, when men displayed courage, grace and verve as they competed for personal honour and the glory of the city states they represented.

Sports occupied a central place in the Greek experience, for the athlete in action epitomized the virtues most sought after by the Greeks: courage, strength and endurance, as well as discipline and restraint under extreme pressure. "Always to excel" (Αἰὲν ἀριστεύειν) was more than a motto: it was a guiding principle, and excellence of any kind was rewarded. At athletic

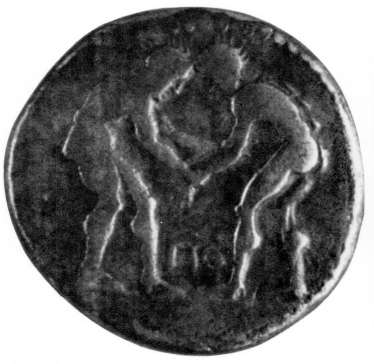

Stater of Aspendos, Pamphylia. Obverse — two youths wrestling. 400-300 B.C. Diameter, 0.222 m. Acc. No. 925.9.6.
Courtesy of the Royal Ontario Museum, Toronto, Canada.

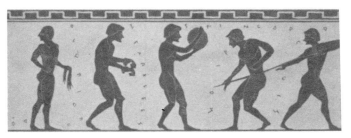

Attick white-ground lekythos decorated with five athletes warming up. From left to right —
Olympiodoros — boxer or wrestler holding fillet
Megaklees — jumper with jumping weights
Spintharos — discus thrower
Dios — runner
Pithis — javelin thrower
Attributed to the Kephisophon Painter, about 500 B.C. No provenance. Height, 0.097 m.; height of frieze, 0.031 m. Acc. No. 963.59. (also slide showing flat projection)
Courtesy of the Royal Ontario Museum, Toronto, Canada.

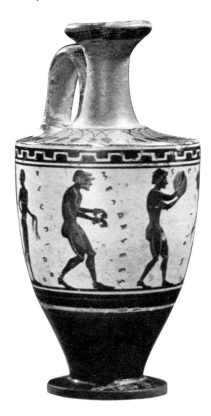

festivals prizes were also awarded for the best poets, painters, sculptors, rhapsodists, dancers and musicians. Indeed, art was much more than an adjunct to the Panhellenic Games: it was an integral part of the festivities, and art competitions were organized at each of the Games.

The original Olympic Games lasted for only one day, and consisted of a single event, a foot race the length of the stadium. Subsequently other events were added: sprints and long-distance races, the discus throw, the javelin throw, the broad jump, boxing, wrestling, the pentathlon, chariot races, and the ferocious pankration, a combination of boxing and wrestling, in which everything was permitted except biting, gouging, and the breaking of an opponent's fingers. With this extended program the Olympic Games, including the religious ceremonies that were an essential part of the festivities, lasted for seven days.

The Games were Panhellenic rather than international, for only Greeks were allowed to participate in them. Competitors came from every part of the Hellenic world, and a sacred truce was declared so that wars were suspended for the duration of the Games, allowing participants to travel safely to Olympia.

Most of the events in the Olympic Games were contested in the nude, and that is how athletes were portrayed in sculpture, and on Athenian pottery of the 7th-4th centuries BC. Before the contests opened, all athletes — who had trained rigorously for at least ten months — swore an oath to Zeus, promising to compete with fairness and chivalry. It is typical of ancient male chauvinism that women were excluded from the Games, both as competitors, and as spectators.

All that the victor received at each of the Panhellenic Games was a garland, which was more prestigious than the crown of any king. Wild olive leaves were awarded at Olympia, laurel at the Pythian Games, wild parsley at the Nemean Games, and pine needles at the Isthmian Games. Victors at the Games became national heroes, and the adulation of their native cities was expressed in various ways. The returning champion was welcomed through an entrance specially cut in the city's walls; he was carried in triumph through the streets; he was granted a lifelong exemption from taxes, and free meals. Athens and other cities added a handsome cash bonus. Beyond these immediate benefits, the hero's immortality was assured: his feats were recorded for posterity in marble or bronze statues, in verse, and in painting.

The great achievement of Greek philosophy was to free man from the spiritual bondage of older civilizations such as those of Egypt and Babylon, which saw man as puny, a plaything of the gods, who existed solely for their sadistic amusement, abased himself before them, and grovelled for favours. The Greeks took the opposite view, and Greek thought was anchored in a firm belief in the dignity and nobility of man. Sophocles, who knew all man's faults, could still sing: "The world is full of wonders, but nothing is more wonderful than man" (Πολλὰ τὰ δεινὰ κοὐδὲν ἀνθρώπου δεινότερον πέλει) Protagoras went a step farther with the bold declaration that "Man is the measure of the universe" (Πάντων χρημάτων μέτρον ἄνθρωπος)

The Greek concept of beauty (τὸ καλόν) applied equally to physical, spiritual and moral beauty. And all these elements can be traced in the Greek attitude to sports. The muscular ape who could hurl a discus or a javelin further than anyone else was not an object of admiration. The force of an athlete's intellect had to match his physical prowess; the blood that ran through his veins had to quicken with what the Greeks called "the sap of the mind" ('Ικμὰς φροντίδος).

The Greeks believed that whatever gifts they possessed came from the gods; their souls were planted with the seeds of immortality. Therefore it was only logical to suppose that by fulfilling their potential they honoured the gods who were the source of their power. The Greeks revelled in the exercise of power, whether in war, athletic competition, or thought. But they always kept a tight rein on their energetic pursuit of excellence by heeding the maxim "Nothing in excess" (Mnoev ayav), and those who tended to be intoxicated by the limitless wonder of man were sobered by the great and famous phrase inscribed above the entrance to the temple of Apollo at Delphi: I vwOt aavrov — Know Thyself.

The long decline of Greece began with the loss of Greek independence after the Roman conquests of the 3rd century BC, which culminated in the annexation of the Greek mainland in 146 BC, when it became a Roman province. The Roman idea of sports was very different from that of the Greeks, as we know from contemporary accounts which describe the bloody and barbarous spectacles in the Roman arenas, where gladiators fought wild animals and each other to the death for the entertainment of the public.

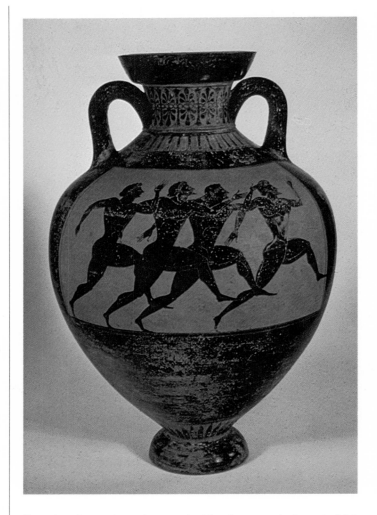

Panathenaic amphora decorated with a footrace. Attic, end of 6th century B.C. Height, about 0.622 m. Acc. No. 915.24.
Courtesy of the Royal Ontario Museum, Toronto, Canada.

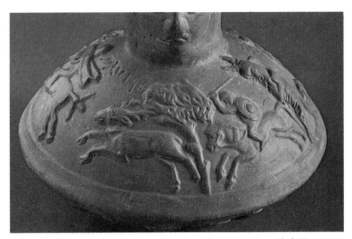

Red-gloss lagynos decorated with a hunting scene in relief. Roman, about A.D. 270-320. Made in the Thysdrus/el-Djem region, North Africa. Height, 0.156 m. Acc. No. 974.139.
Courtesy of the Royal Ontario Museum, Toronto, Canada.

It is not known for certain whether the Panhellenic Games were held with any regularity after 261 AD. The Christian emperor Theodosius I, prompted, it is said, by St. Ambrose, issued an edict in 394 AD, abolishing all pagan cults, and closing down all pagan centres of worship. Since the Games at Olympia were manifestly pagan, it is unlikely that they were held after that date. It was not long before one of the temples at Olympia was converted into a Christian church; barbarian raids and a couple of earthquakes completed the destruction of Olympia, and the site remained hidden until 1766, when it was discovered by a visiting Englishman. It was excavated briefly by the French, and later by the Germans in the 19th century.

The history of athletics between the fall of Rome in the 5th century and the 19th century is very patchy. At religious festivals in the Middle Ages there were primitive ball games between rival towns and guilds, which were probably embryonic versions of modern spectator sports like soccer, baseball, tennis, football and hockey. Contests of strength and skill were often staged at harvest fairs. But rulers in medieval Europe encouraged only martial sports which trained skills useful in war: archery, shooting, riding and hunting.

The hunt has appealed to the imagination of the artist from the earliest times, providing him with one of his most durable and compelling themes. Prehistoric cave paintings of remarkable sophistication convey the danger and excitement of hunting wild animals, though it was done not for sport, but to replenish food supplies. Egyptian wall reliefs have preserved the splendour of royal hunts which were a form of religious ritual, underlining the Pharaohs' divine status. Roman mosaics in Sicily record the capture of wild animals in North Africa, from where they were transported to arenas, to be slaughtered in circumstances of horrifying cruelty.

The hunt was a favourite subject of medieval painters. Paolo Uccello's *Hunt in the Forest* is a picture of great charm and elegance, with blood and death distilled out of it. In 18th century England George Stubbs painted a quintessentially English ritual: the foxhunt — aptly described by Oscar Wilde as "The unspeakable in full pursuit of the uneatable".

Medieval Europe was dominated by the Roman Catholic Church, and

the Holy Roman Empire. With the rise of Christianity, the emphasis in thought shifted from the physical to the metaphysical. To a medieval thinker, the notion that man is the measure of the universe would have smacked of heresy. Man was instead a wretched, fallen creature, tainted with original sin, and imprisoned in mind if not in body. He led a brief and brutish existence, the creation and victim of a cruel, vengeful God who demanded absolute servility as the price of salvation. It was not until the Renaissance that man assumed his accustomed place in nature as "the paragon of animals".

Europe had reeled under successive waves of barbarian invaders, and the fabric of her society was in tatters. The ruins of the Roman forum, where cattle grazed, was a metaphor for European culture — broken, and overrun with weeds. War and pestilence caused a continual haemorrhage. The Black Death reduced the population of Europe by a third. A warrior caste of boorish knights and barons made sure that "the clang of armour was as common as the church bell".

Whatever wealth could be wrung from this society was used to build churches and castles. Yet for all the excesses of the ascetics and the brutalities of the warrior elite, trade and scholarship kept the enfeebled continent alive with transfusions from the classical past; and the enduring legacy of Greece survived like a resistant and indestructible bacillus in the bloodstream of Europe. The Greek vision of human excellence and the intrinsic worth of the individual man was to become an article of faith during the Renaissance.

Baldassare Castiglione (1478-1529), in his famous book *The Courtier (Il Cortegiano),* described the complete man *(l'uomo universale)* who should be of refined taste and good manners, capable of riding and hunting, but also possessing a knowledge of the classics, and an appreciation of music, painting, sculpture and architecture. He was to wear his learning lightly, without pedantry, nor was he to allow his sensibilities to be hardened by professionalism.

Men like Lorenzo de Medici came close to this ideal; he was the patron of a constellation of geniuses which burst into the dark cultural firmament of Europe during the Renaissance. Once more art was recognised as a civilising and redemptive force, though it now drew its inspiration from Christian and classical mythology. Art is a mirror of society, reflecting its confidence and aspirations as well as its doubts and confusions. The classical influence is unmistakable in the work of Renaissance artists, but so too is the Gothic; and Greek serenity is notably absent in the turbulent and tragic nudes of Michelangelo.

It was not until after the Industrial Revolution in England, four centuries later, that an interest in sports began to stir in the minds of enlightened educators. Thomas Arnold introduced sports as a regular extra-curricular activity at Rugby, and other public schools quickly followed his example. This led to a great sports revival during the Victorian age, and it is at this point that an aristocratic Frenchman, Baron Pierre de Coubertin (1863-1937), enters our story.

Coubertin wisely adapted the Olympic program to contemporary realities, so that of the 42 events in ten sports, only a few would have been familiar to the ancient Greeks. The rest — hurdling, cycling, the high jump, fencing, and so on — were designed to appeal to modern athletic interests. The ancient Olympic ideals, however, remained intact.

Coubertin was a distinguished educator and scholar, but not an athlete. He followed the German excavations at Olympia with the keenest interest, and he was inspired with a brilliant and far-reaching idea which became the dominant passion of his life: the revival of the Olympic Games. "Germany," he wrote, "has brought to light the remains of Olympia; why should France not succeed in reviving its ancient glory?" This splendid proposal was discussed at an international conference at the Sorbonne in Paris in 1894, where it was given a tepid reception. Nevertheless an International Olympic Committee was set up in 1895, and the first modern Olympic Games were held in Athens in 1896.

In keeping with that spirit, art competitions were organized as part of the modern Games. Competitions were held in architecture, sculpture, reliefs, graphic art, drawing, watercolour painting, engravings, literature, opera, drama, poetry and music. Regrettably, all official Olympic art competitions were abolished at the London Games in 1948, and have never been reintroduced in any of the subsequent Games.

Pierre de Coubertin expanded the original concept of the Olympic Games by making them truly international, for he saw sports as a way of bringing nations together in a spirit of fierce but friendly rivalry which would transcend political, national and ideological boundaries. Inevitably, the reality fell short of the ideal; but it did not fall so short that Coubertin's great and noble experiment in universal brotherhood could be written off as a failure.

There is no doubt that the revival of the Olympic Games gave a tremendous impetus to the renewed interest in sports which had begun in Victorian days. To excel in athletic competition became a matter of national as well as personal pride; the seeds which had germinated after an incubation of nearly twenty centuries were now brought to a glorious flowering.

It was a phenomenon which ignited the imagination of some of the most significant artists who had emerged in America in the 19th century. The greatest of these was Thomas Eakins (1844-1916), one of the unquestionably major artists America has produced, although the quality of his genius was not recognised until after his death. Eakins had an abiding interest in sports and the outdoors, and made them the subject of some of his finest paintings in oils and watercolours. In choosing his themes Eakins cast his net wide, and depicted sculling, wrestling, boxing, baseball, hunting and sailing.

In *The Champion Single Sculls* (1871), also known as *Max Schmitt in a Single Scull,* Eakins produced a memorable portrait of his friend the sculler Max Schmitt, as well as a superb picture of sculling. The setting is the river Schuylkill in Philadelphia, Pennsylvania, and Schmitt is shown in the foreground, resting from his rowing exertions. He sits in a sleek, shallow scull, looking over his right shoulder at the viewer, his eyes narrowed against the glare of sunlight. His expression is as calm and opaque as the bottle-green water on which his scull floats.

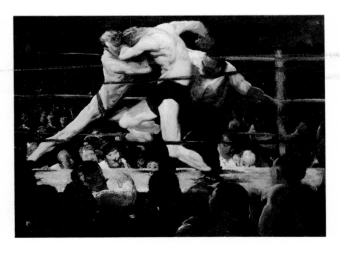

Stag at Sharkey's. "The Cleveland Museum of Art, Hinman B. Hurlbut Collection."

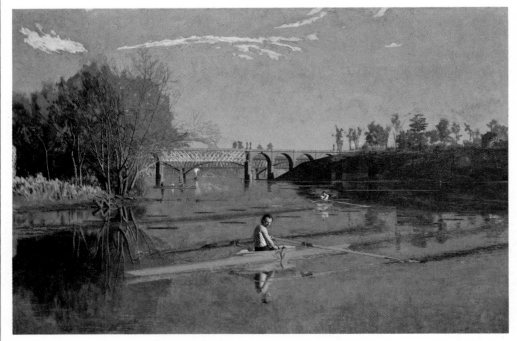

Max Schmitt in a Single Scull. The Metropolitan Museum of Art, Alfred N. Punnett Fund and gift of George D. Pratt, 1934.

In the middle distance Eakins has portrayed himself in another single scull, pulling strenuously on the oars, and about to enter the shadow of the two railroad bridges which define the background of the picture. Eakins's meticulous attention to details of anatomy and perspective is evident in this painting, from the sensitive moulding of Schmitt's high, bony head to the fine draughtsmanship displayed in the drawing of the sculls. The iron trestles and stone arches of the bridges, the reflections of the trees growing on the left bank of the river, and the ripples left by the blades of Schmitt's trailing oars, are rendered with breathtaking fidelity and skill. The light is manipulated in a highly original way to create a mood of quiet exhilaration in the afterglow of physical effort, as well as suggesting a private mental world that the viewer cannot hope to penetrate.

Sports paintings comprise only one segment of Eakins's work. He was an incomparable portrait painter, as witness the great *Portrait of Professor Gross,* one of the central masterpieces of American painting. Eakins was also a pioneer in the fledgling art of photography, making excellent studies of friends and students, individually or in groups, which he later used to supplement his own observations. This helps to explain the uncanny accuracy and detail in pictures like *The Swimming-Hole* and *The Wrestlers.* Like Eadweard Muybridge, Eakins made several experimental photographs of figures in motion; the knowledge he acquired in this way was applied to both painting and sculpture.

It is curious that Eakins chose to portray boxers in rather static moments *(Between Rounds*; *Taking the Count*; *Salutat).* George Bellows (1882-1925), on the other hand, painted boxers in combat. In *Stag at Sharkey's* (1907), the figures of the two fighters surge with energy, and attack with such ferocity that their heads seem to be fused, their limbs enmeshed. The paint is applied thickly, and the heavy swirls capture the action of the writhing, contorted bodies with marvellous realism. The atmosphere of a stag night at Tom Sharkey's Athletic Club in New York City is conveyed with similar authenticity. It is redolent of smoke and sweat, and the brutal faces of the spectators at ringside — exultant, tense with the expectation of blood, cigars pronged between their teeth — are shown with graphic and unsentimental honesty.

"For the first time in 2,000 years sport has rewon her laurels in the field of art," wrote Malcolm Vaughn in the New York *Herald Tribune* in August 1928. He was commenting on the exhibition of art at the 1928 Olympic Games, and he singled out for special praise the work of "America's most famous sculptor of sport" — Robert Tait McKenzie.

McKenzie was actually a Canadian, born to Scottish immigrant parents in Almonte, Ontario, in May 1867. He was an extravagantly gifted man, an anatomist, sculptor, artist, musician, author, teacher, gymnast, and physician, who fulfilled the Greek and Renaissance definition of the complete man.

It was to the Philadelphia of Thomas Eakins that McKenzie went in 1904, after obtaining his medical degree at McGill University. At McGill he had been a champion gymnast and high jumper, as well as medical director of physical training. At the University of Pennsylvania he was appointed director of physical education, and he used the post as a springboard for an inspired leap into a parallel career as a sculptor of athletes. Noting that Greek athletics were bequeathed to us by their poets and sculptors, McKenzie declared: ". . . it now remains for the modern artist to put into imperishable form the power beauty and virility of this great athletic revival in the midst of which we live."

How well McKenzie succeeded in doing this may be seen from his fine bronze statuettes, of which *Sprinter* (1902), and *Competitor* (1906), are among the most striking. McKenzie chose to portray his athletes in the nude, in the classical tradition of ancient Greece.

The *Sprinter* crouches, as lean and eager as a greyhound, waiting for the sound of the gun, the signal that will galvanise him into action. His muscles ripple with controlled energy; his body's potential for speed is suggested both by its streamlining, and its stance, with the sprinter's weight resting lightly on his toes and curled hands, in the moments before he unleashes his power.

Competitor is a finely sculpted figure of a runner tying his track shoe. It does not seem to have occurred to McKenzie that the sight of an athlete wearing nothing but track shoes would not only be paradoxical, but comical. Aside from that one anomaly, *Competitor* is a highly successful sculpture which conveys the subdued excitement of an athlete getting ready for a supreme effort on the track. It is amazing how McKenzie was able to express through the stillness of metal the tension and strength harnessed within the lean, supple body of the athlete. The pyramidal composition adds to the feeling of contained energy. Both *Sprinter* and *Competitor* are examples of how McKenzie's thorough knowledge of anatomy, acquired as a physician and physical educator, contributed vastly to the authenticity and dynamic force of his figures.

McKenzie never used the human body as a vehicle for expressing moral and spiritual conflicts in the way that Michelangelo and Rodin did in their majestic and tormented nudes. McKenzie's aims were simpler and narrower: he was concerned with showing "untrammelled youth" in the joy of physical

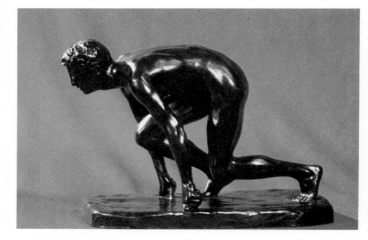

The Sprinter, Private Collection, Montreal, Quebec.

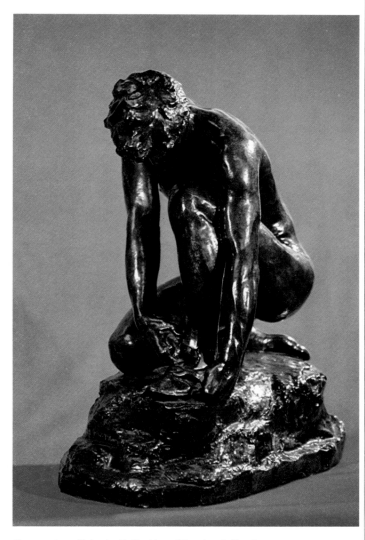

Competitor, Private Collection, Montreal, Quebec.

action, a model which is summed up in the phrase "the eager mind in a lithe body", adapted by McKenzie from the famous Latin motto *Mens sana in corpore sano:* A sound mind in a sound body.

A detailed discussion of McKenzie's sculpture — the bas-reliefs, the experimental works and the monument commissions — is outside the scope of this essay. So too is an examination of the valuable contribution he made in pioneering physical rehabilitation programs for victims of World War I. Suffice it to say that he laid the foundation for most of the physiotherapy still practised in hospitals today.

McKenzie loved America, but he never surrendered his Canadian citizenship. When he submitted sculpture to Olympic competitions, he always did so as a Canadian. He remained faithful to his Canadian heritage, and to this was added a romantic attachment to the Scotland of his ancestors. During the later years of his life he spent his summers in Almonte, Ontario, in a converted mill which served as both a summer home and a studio. McKenzie died in Philadelphia in 1938. Sadly, his art has been underrated, and forty years after his death he has not yet been accorded a stature commensurate with his many achievements.

But a step has been taken in the right direction. In 1969 the federal government's Task Force on Sports for Canadians expressed the following hope: "It may be that out of the welter of sports bodies in Canada one organization may emerge, capable of speaking for the whole amateur sports spectrum, and providing unified leadership for it." On the recommendation of the Task Report, the National Sport and Recreation Centre was founded in Ottawa in September 1970.

The Centre houses the permanent staff of nearly sixty national sport and recreational organizations. It provides those organizations, as well as more than thirty specified non-resident organizations, with common administrative services as well as an opportunity for exchange of ideas and information. The Centre is funded by Sport Canada and Recreation Canada, sections of the Fitness and Amateur Sport Branch of Health and Welfare Canada. But government funds do not tie the Centre to government bureaucracy. Its employees are not civil servants, and its President is responsible only to his Board of Directors.

A unique collection of sports art is housed at the Centre. It consists of some 200 paintings, sculptures, and other visual arts by Canadian artists. The Canadiana Sport Art Collection is displayed at the Centre, and moved on request throughout the country.

In 1974, the then Vice-President of Promotion had an idea. He proposed that a Chair be established, to be used as a base from which distinguished Canadian professionals could pursue their speciality in relation to sports. It was hoped that by doing so they would emphasize the importance of the relationship between sports and culture, and contribute substantially to the public's awareness and appreciation of sports as an integral part of Canadian culture.

He received enthusiastic support for his idea from the President of Labatt Breweries of Canada. Labatt's agreed to fund the Chair, which was named after R. Tait McKenzie, in recognition of the impact he has had on Canadian sports culture. And in 1975, the realist painter Ken Danby was named the first recipient of the Robert Tait McKenzie Chair for Sport.

The artist's forebears had farmed the area around Sault Ste. Marie, Ontario, for generations, but his father was the city's Assessment Commissioner until his retirement in 1974. In 1934 Edison Danby married Gertrude Buckley, who comes of an English immigrant family which settled in Canada when she was nine years old. The Danbys had two sons. The older, Marvin, was born in 1936. His brother Ken was born four years later, on March 6, 1940.

Ken had a happy childhood. He roamed the countryside around Sault Ste. Marie, responding intuitively to the romance of the Ontario landscape. He was unconsciously honing his remarkable powers of observation, and nothing in that immense landscape escaped his scrutiny. His curiosity was insatiable, and he examined his environment with eyes that were like a grasshopper's magnifying mirrors.

It is to the landscape of rural Ontario that his imagination constantly returns on an endless pilgrimage, providing him with the inspiration and the imagery for his art. His visual memory is faultless, and from it he has drawn a series of vignettes of young boys running through fields of long grass, bicycling on deserted country roads, balancing on fences, sitting in trees, or just dreaming in the brief morning of their lives. These images are a nostalgic and moving reflection of Danby's own boyhood.

By the time he was ten, he had decided that his vocation was to be an artist, and he nurtured the hope of one day attending Toronto's Ontario College of Art. In school in the meantime he became actively involved in track and field as well as team sports, which gave him a participant's insight into sports. The experience was invaluable when he came to create the images in this book.

Ken Danby's present position as Canada's finest realist painter was not won without a struggle. When he came to the Ontario College of Art as a youth of 18, he had already been drawing and painting realistically for a number of years. But at the College of Art he was confronted with abstract expressionism, which was all the rage at the time. Danby reluctantly attempted to mine what was considered an inexhaustible lode, but for him it was a meagre seam which soon petered out. He did paint some striking abstracts, but he remained dissatisfied; he was working against his natural instincts, and he knew it. One of his teachers, the late J. W. G. (Jock) Macdonald, was sympathetic, and when Danby decided to get out of academic harness after two years at the College of Art, Macdonald encouraged the move.

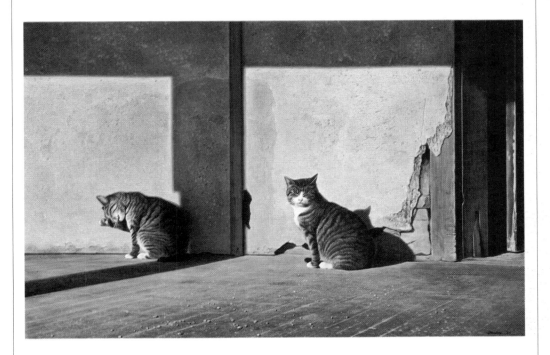

Partners, Egg Tempera, 1973, 20" x 30" ,Private Collection ·

Danby then led a nomadic existence in Toronto, moving from room to room with a menagerie which included an ocelot among the cats, hamsters, and goldfish. He painted sets in a television studio, dressed up mannequins in a women's wear shop, designed chocolate bar wrappers, and worked in the layout and illustrating section of the promotion department of the now defunct Toronto *Telegram*. Throughout this unsettled time Danby's artistic ambitions never wavered, and he continued to draw and paint. He made a determined attempt to get a positive response from art dealers, but they showed little empathy with his art. Then he showed some of his work to Walter Moos, who indicated a warm and definite interest in the work.

"Walter Moos was a very opportune and a very welcome encounter," says Danby. "I had reached the end of my rope. I had done some oils and drawings of quite realistic imagery, all under the grand suspicion that it was fruitless, that it was naïve work, because it wasn't in the accepted form of contemporary art. I had gone to Walter Moos, having approached other dealers previously without success. He was the only one who said 'Yes', and actually purchased some of my work, which was exactly the kind of encouragement I needed at the time. He had confidence, interest and belief in what I was pursuing; and about a year and a half later I won the Jessie Dow Prize for *Fur and Bricks* at an exhibition in the Montreal Museum of Fine Arts. That was my first major success."

Danby has never looked back since that first success, which brought him to national attention. Walter Moos has remained his dealer and friend, and in Toronto the artist's work is exhibited exclusively at Gallery Moos in Yorkville.

In 1967, Danby bought the century-old Armstrong Mill northeast of Guelph, situated on eleven and a half acres, and moved into the miller's house with his beautiful and ebullient wife Judy, his son Sean, and a Great Dane named Timber. The mill itself, an imposing limestone structure, is being renovated as a future residence and studio. Danby's present studio is a later building, erected on the site of an old barn, and stands about a hundred yards away from the house. The Speed River is like a shattering of stained glass as it races over its bed of many-coloured stones, and great willows grow along its banks where it runs through the Danby property. It is a quiet and private place which has provided the artist with the settings for some of his most memorable paintings.

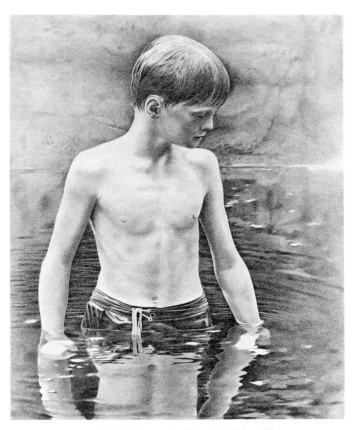

The Swimmer, 1970 Lithograph, 23 x 18 Edition 75

Ken Danby is a darkly handsome man, six feet tall, with a powerful physique and the lithe, loping stride of an athlete. He dresses casually, in faded, comfortable blue denims. His voice is low and warm, his conversation rich with humour. He is articulate, but not glib; he has a reflective mind, and quick, clever answers do not trip off his tongue. His speech, like his movements, is unhurried and deliberate. (As a visual communicator, Danby has an eloquence few can approach; much of what he has to say is said with pencil and pigments.) Danby's manner is friendly and direct, without a trace of arrogance or affectation. But the inner core of the man remains inaccessible, fenced off with psychological barbed wire.

As a painter Danby is largely self-taught, and he opted for egg tempera as the medium best suited to his themes and temperament. He explains why: "Having gone through every medium imaginable, I found that egg tempera was the one most suited to my needs. There is a fallacy that egg tempera is only suited to those with a great deal of patience: in fact the opposite is true. With egg tempera you're drawing with paint rather than moving paint about on a surface, and that aspect of it appealed to me. I could work on it immediately and get immediate results; my impatience was being served by a medium which allowed me as much flexibility as I needed. It is the only medium which allows the artist to literally control the intensity of light both in its degree of penetration and in its reflection. It is also the most permanent painting medium known to man."

Danby mastered the medium very early in his career, and by the beginning of the 1970's had broadened the scope of what had hitherto been regarded as a notoriously limited medium. *Partners* was painted in 1973. It is a picture of two brindled cats sitting in a flood of sunlight on the porch of an old mill. One cat squints directly into the light, while the other, preoccupied with its personal hygiene, licks its paw fastidiously. The background is a beautiful abstract composition in which Danby has indulged his special fondness for colour, texture, and patterns of light. Two great squares of sunlight are projected on the wall behind the cats, and the plaster, though faded, is warmed to a gorgeous salmon pink. Where the wall is in shadow the pink deepens into a rich burgundy. In one corner the plaster has crumbled away, exposing the grey stone blocks beneath. Danby's virtuoso technique enabled him to render different textures with amazing skill. He caught the brittle roughness of old plaster, the worn and weathered wooden door frames, the lovely sheen of cat fur. The fine brushwork, as well as the confident control of light and colour pointed to the hand of a master.

There is a part of the Speed River which is relatively still, and this is a water hole where the mill dam used to be. One day in 1970 Danby saw a neighbour's son standing waist-deep in that pond, looking into the water like a spellbound Narcissus. Danby made a lithograph of the boy; it is a superb anatomical study of a young male torso, and the artist's observation encompasses every detail of the subject, from the limestone rock in the background, to the boy's wet hair, to the limp draw-strings knotted round his waist. The reflections are done with scientific accuracy, showing the refraction of the boys hands below the surface of the water. This lithograph was a preliminary study for what was to become *Reflections,* (1970), one of Danby's most ambitious and successful temperas.

Danby's explorations in the technique of egg tempera painting continued, and he discovered that there was practically no limits to the medium. "It was tremendously exciting," he says of that time, "I couldn't believe the things that were happening to me in the early 70's, just technical achievements, a kind of uncovering of the unknowns which came just by exploring the medium and responding to what it was capable of doing. It was a tremendous insight and revelation for me, because I had no idea that any medium could offer so thorough a range."

But Danby's fascination with egg tempera did not blind him to the merits of other media. *Blue Hood,* a tender, intimate portrait of his wife Judy, was painted in watercolours in 1976. It shows a strikingly beautiful woman in a hooded warm-up jacket of blue velour. Her face is framed by the blue hood, and her own silken black hair; her fine dark eyes are lowered, and express both tenderness and humour. There is strength as well as humour in the smile of the wide, mobile mouth. This loving portrait, executed in the most delicate washes of colour, is the result of a painter's gazing into a woman's soul, and recording that interior journey. Behind the beautiful face is revealed a woman of exceptional sensitivity, passion and endurance.

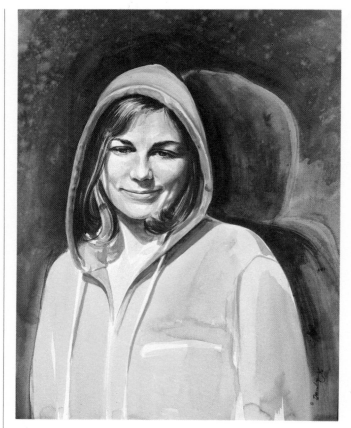

Blue Hood, Watercolour, 1976, 13 1/2" x 10 1/2",
Private Collection.

Danby portrayed another member of his family in *Looking In* (1974) a serigraph (silkscreen print) of his eldest son Sean at a window. With the sun behind him, the eight-year-old boy stares intently through a window pane, his shoulders hunched in introspection. The picture is a testament to the accuracy of Danby's observation of light phenomena. Direct sunlight on a window makes the glass opaque; but where there is shadow — in this instance caused by the boy's head and shoulders obstructing the light — that area is clear. The shape of the shadow is a laterally inverted, or mirror, profile of the boy's head.

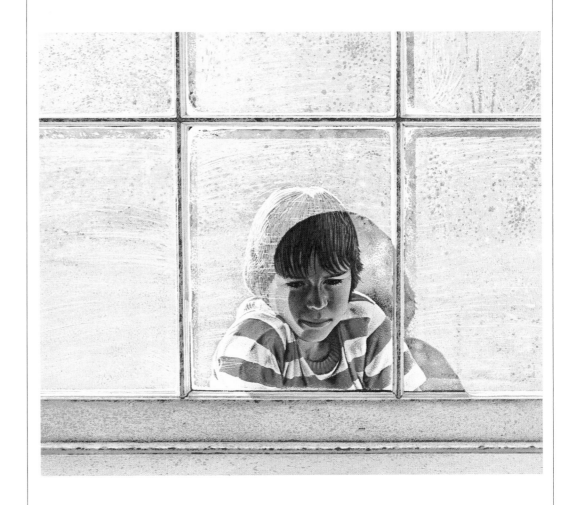

Looking In, Serigraph, 20 colours, Edition of 250, 1974, 11 3/4" x 11 3/4".

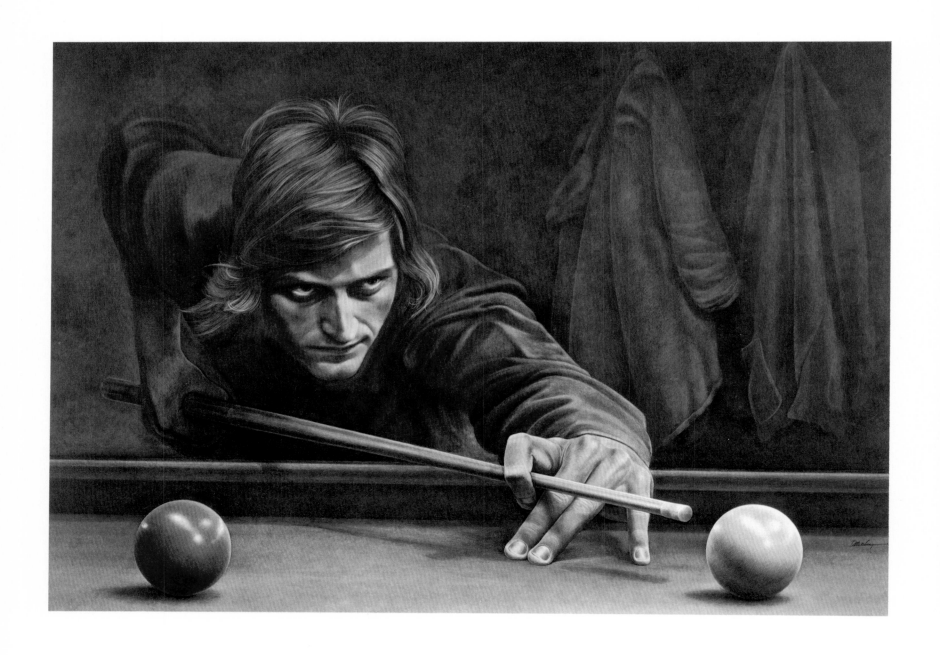

Snooker; 1971 Egg Tempera 22 x 32; Private Collection, New York, N.Y.

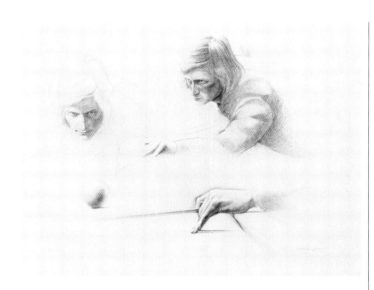

Study for Snooker; 1971 Pencil Drawing 21 3/8 x 26 3/8;
Private Collection, New York, N.Y.

Snooker, (1971), was Danby's first attempt to use sport as the subject for a major tempera. Danby's pencil studies show how he approached the final image. In his search for maximum drama, he decided to confront the snooker player at eye level, from directly across the pool table. It is a marvellously atmospheric picture, revealing Danby's increasing confidence in his handling of light. The illumination is soft and subdued. The tense facial muscles of the player are limned with light as he stares with hypnotic concentration at the gleaming ball. The bony knuckles of his rigid left hand are starkly defined; the forefinger is crooked over the cue, the remaining three fingers are planted firmly on the green baize of the table's surface. Their tips flatten and the nails whiten as the player presses downward to steady his hand. The blue chalk on the tip of the cue glows like a pale sapphire.

Some of Danby's most amazing achievements have been in serigraphy, a silkscreen process which he has extended to accommodate as many colours as he wishes to include. This is a far more personalized process than the "limited editions" which are reproduced photo-mechanically and offered as collectors' items. "What I was trying to find initially was a method of creating an original print with as fine a fidelity or as close to it as an actual painting would allow," explains Danby. "And to do that is a very difficult procedure, because the very essence of the graphic process is to reproduce from a stencil or from a plate, and the limitations of the medium itself often restrict what results can prevail. I discovered certain aspects of the silkscreen medium that would allow me to control the intensities, opacities, translucency and so forth of the inks, and allow fine registration with a proper printing table.

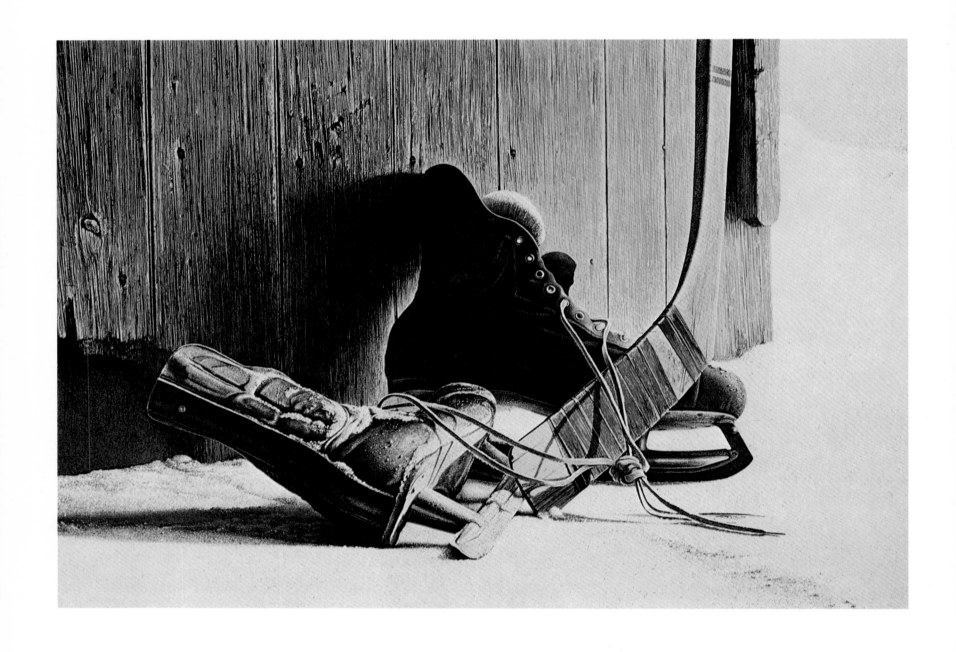

The Skates; 1972 Colour Serigraph 18 x 24, 22 Colours; Edition of 100.

Study for The Skates, 1972 Watercolour, 13½ x 22; Collection Mr. Alan Eagleson, Toronto, Ontario.

"What I do is incorporate the approach of egg tempera, a procedure of analysis and structuring of the image with paint, that I follow when creating a silkscreen print. By allowing myself the freedom of an intuitive response rather than a predetermined course I allow the print to develop as I work on it. The colours the image will have, and the extent of clarity and completeness of the image, will be determined at each stage of its metamorphosis. It is I who respond to the print, and not the other way around, and that is what is so innovative: my approach to printmaking. I *don't* create a master image which I then reproduce through a graphic process. But in fact I allow the image to work up from a sketch form in a print to a completed print in the final proof."

This is what Danby did with *The Skates* (1972), which he worked up from a watercolour sketch to a 22-colour serigraph in a limited edition of 100. Of these, 37 were presented by Danby and Moos to members of the Canadian hockey team, to celebrate their victory over the Russian National Team in 1972. The picture shows a pair of skates and a hockey stick discarded after a game. One skate lies on its side, dusted with powdered snow; the other, with a woollen sock stuffed into it, leans against a worn wooden door. The laces of the skates are knotted loosely together, and in the weak winter sunlight cast their wormlike shadows on the taped blade of the hockey stick. All these objects show signs of long and hard use, and there is an odd feeling of weariness and abandonment in this picture.

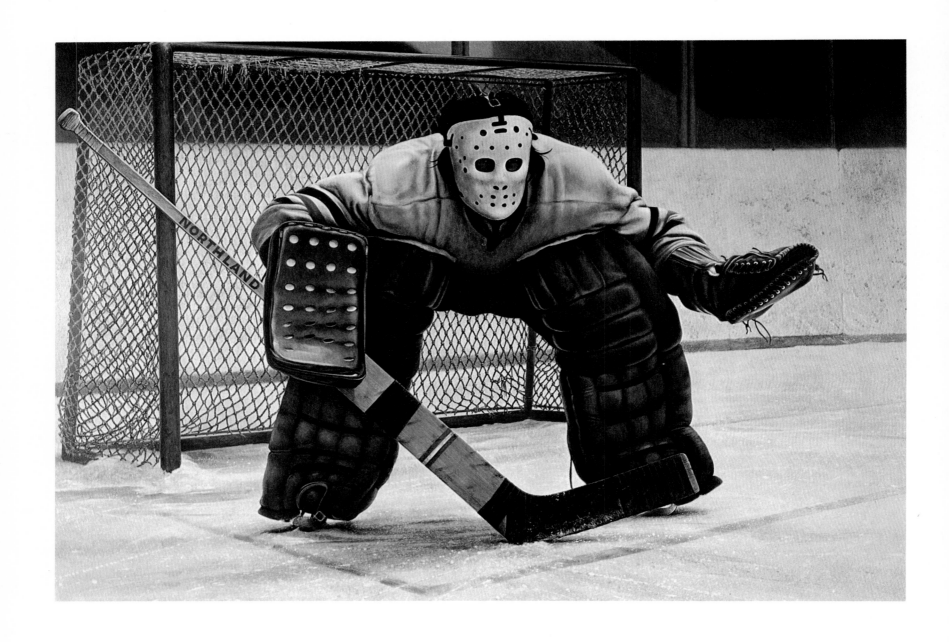

At the Crease; 1972 Egg Tempera 28 x 40; Private Collection, Toronto, Ontario.

Study for At the Crease; 1972 Watercolour and Pencil, 21 x 26 3/8; Private Collection, New York, N.Y.

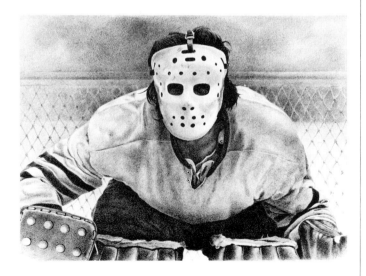

The Goalie; 1972 Lithograph 18 x 23; Edition of 100.

There is no such ambiguity about *At the Crease* (1972), one of Danby's masterpieces in tempera. The idea for the painting came to him when he saw a neighbour's son wearing a mask as he played goal. Danby had not played hockey for a decade, and during that time the goalie's mask was introduced. His first sight of it haunted him for weeks, and after a long period of gestation all the elements which went into the painting coalesced in his mind, and he created an unforgettable image of a goalie bracing himself as he anticipates a shot which could send a puck streaking at him at speeds of up to 100 m.p.h. The figure, with its massive leg padding, and huge padded gloves, is formidable as a tank. Its face is covered with a sinister white moulded mask which is like a perforated skull. The goalie looks invincible, but the small, bright, apprehensive eyes behind the mask tell of his isolation and vulnerability as he defends that rectangle of netting behind him.

The picture is a *tour de force* by Danby. In it he displays all the virtues of his matchless art: impeccable draughtsmanship, accurate perspective, and an unobtrusive geometrical structure underlying the composition. The ice on which the goalie stands is translucent, its surface scored by skates and sticks. Every knot in the mesh of the goal net is faithfully rendered; so is the plump softness of leather and padding. The tenseness and excitement implicit in a goalie's crouch which was caught in the swift, confident brushwork of the watercolour sketch is transferred without loss into the more finished image of the tempera painting.

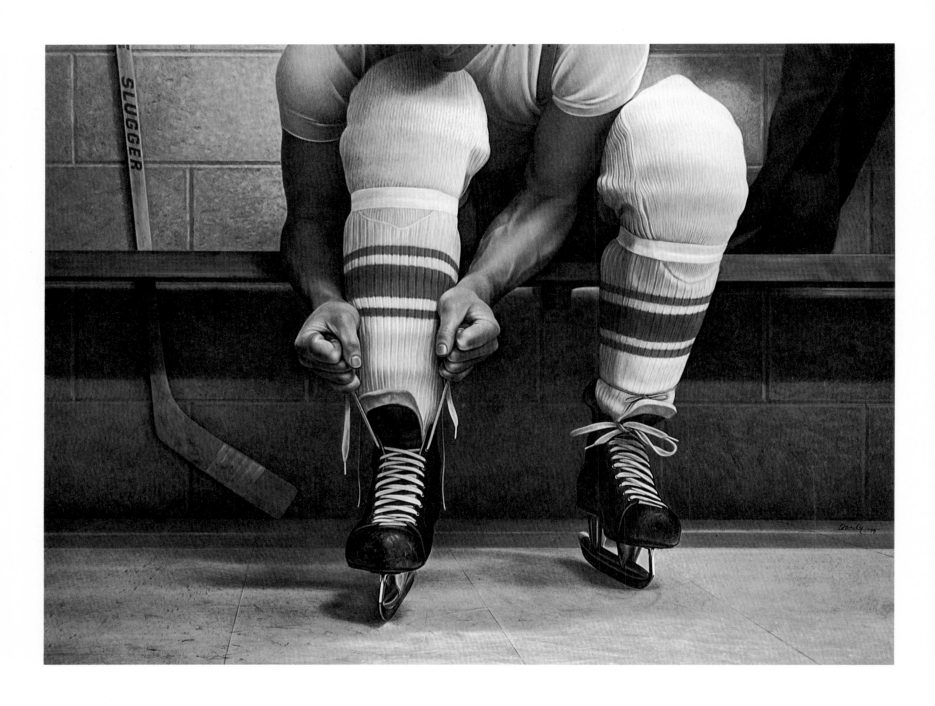

Lacing Up; 1973 Egg Tempera 22 x 32; Collection, Mr. John F. Bassett, Don Mills, Ontario.

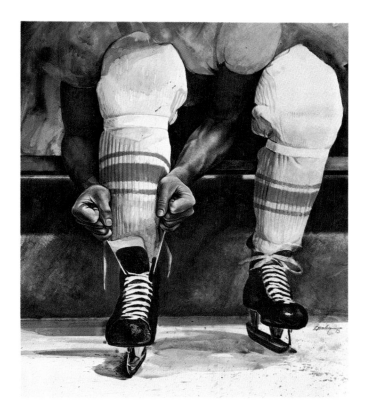

Study for Lacing Up, Watercolour, 21 1/4" x 17 1/2", 1973, Mr.Bobby Orr, Chicago, Illinois.

Danby expressed his love of hockey once more in *Lacing Up* (1973). The picture is composed of the simplest elements: a wooden bench against a wall, a hockey player sitting on the bench and lacing up his skates. The perspective is an unusual one. The viewer would have to be sitting on the floor in front of the player to see what he is offered here. We are not shown the player's face, except for his chin, mouth, the tip of his nose. Yet every line in that strong body expresses courage and toughness, and an eagerness to engage in combat. The player is like a medieval knight buckling on his armour before going into the lists. His legs, sheathed in ribbed woollen stockings, are like pillars of oak, and his powerful arms — pulling so hard on the taut laces that the veins bulge — look as if they could fell an ox.

Danby's watercolour studies allow a rare insight into the artist's mind, as he tests out the viability of his ideas, and seeks ways of "resolving the image" he is after. All the ingredients of his finished temperas are in these sketches, but in microcosm. In his study for *Lacing Up,* Danby has already found his focus; and his emphases, on the tree-trunk legs and the muscular arms with their serpentine veins, are the same as those in the final image.

In June 1974, Danby won a competition to design Series 3 of the Olympic Coins to be issued by the Royal Canadian Mint in honour of the 1976 Olympic Games to be held in Montreal. The conditions for the competition specified that "The designs on the coins must depict early Canadian sports that have a clear identification with the summer Olympic Games. . .." Danby chose to depict rowing, canoeing, lacrosse and bicycling.

The rowing design ($5 coin) shows a sculler viewed full face. His hair style and moustache, and the design of his scull, suggest an earlier era. His arms are outstretched, at the beginning of his stroke. The canoeing design ($5 coin) shows the herculean back of an Indian brave as he paddles his canoe. His head is turned in the direction of the world "Olympiade". The lacrosse design ($10 coin) is a group portrait of four Indian braves participating in the sport of their own invention. The bicycling design ($10 coin) is a charming group of 19th century Canadian bicyclists riding their rather ludicrous penny-farthings.

All these sports are historically traditional in Canada, and lacrosse is legislated as the country's national sport.

While he held the R. Tait McKenzie Chair, Ken Danby created a series of watercolours depicting some of the Olympic sports for the National Sport and Recreation Centre. Danby agreed with McKenzie's claim that "nothing is more beautiful than the figure in the flower of its youth showing its strength, grace and agility in the sports and games of the playing field, swimming pool and gymnasium."

But Danby was also fascinated by the psychological as well as the physiological demands made on an athlete. He saw close parallels between the

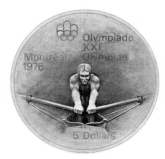

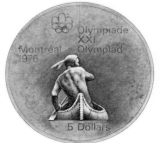

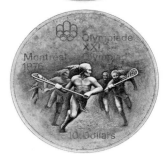

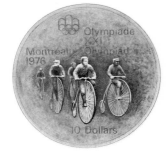

Preliminary sketches for series III, Olympic Coins; 1974 mixed media 7 1/8 dia.

lonely dedication of the athlete, and the devotion of the artist who secludes himself in order to achieve the goal he has set for himself. Both the athlete and the artist must enter the labyrinth of his own being in order to face unflinchingly the truth about his own nature, and seek out for himself the limits of mind and body which only he can determine. An athlete in Olympic competition strives against the world's best athletes; but like the artist, he is ultimately competing against himself.

It was this aspect of the athlete that Danby wanted to reveal, and he chose for his subjects a diver, a sprinter, a gymnast, a sculler, a high jumper and a cyclist. Each image would feature an individual athlete, thus retaining a certain visual continuity through the six works. Since these figures were to represent international athletes, and not just Canadians, no identifying logos, crests or symbols would be shown on the costumes. "The images," Danby stated, "will simply represent proficient amateur athletes engaged in their particular events, which of course, is also in line with McKenzie's work."

At first Danby thought he would use these watercolours as studies from which to develop meticulous egg tempera paintings, as he had done with *At the Crease*. But he abandoned that idea. He wanted to express excitement and fluidity, and this could best be done in watercolours which combined spontaneity with a considerable degree of detail.

In order to achieve an accurate depiction of the activities represented, Danby worked with some of the best Olympic athletes in North America. He travelled to various centres to sketch and photograph them, and he also worked with athletes at the Pan American Games in Mexico in 1975.

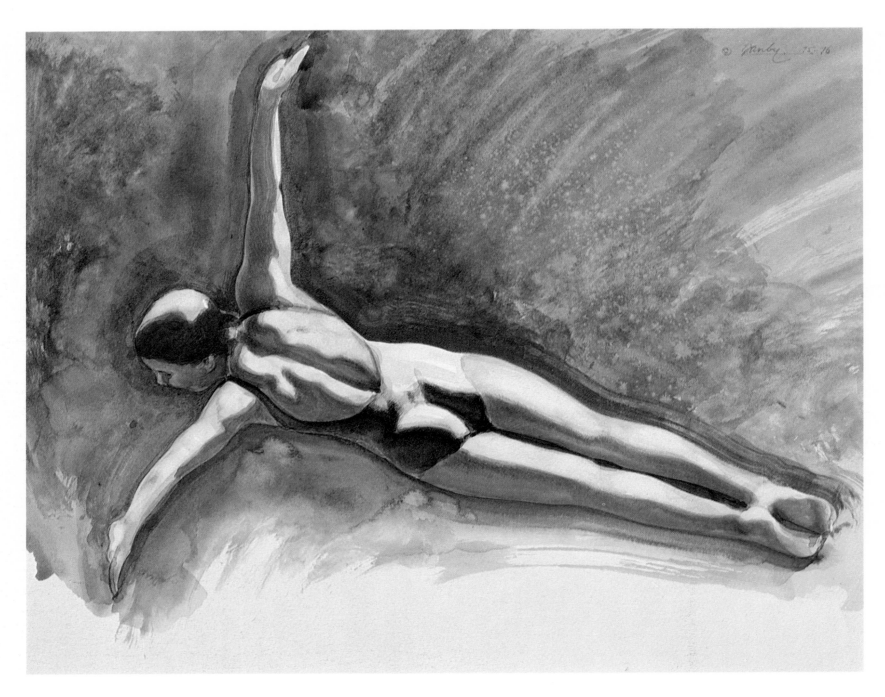

Top of the Dive, Watercolour, 10 1/2" x 13 1/2", 1976, Private Collection.

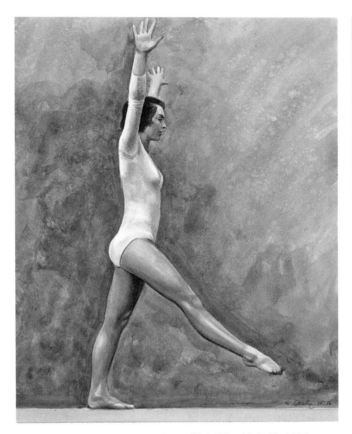

Walking the Beam, Watercolour, 10 1/2" x 13 1/2", 1976,
Private Collection.

In *Top of the Dive*, a preliminary sketch for *The Diver*, Danby caught a
female diver in midflight, soaring with arms spread horizontally from her
body, her legs welded together. She seems to hover like a kestrel before
succumbing to the gravitational pull that will send her slicing into the water
below. The diver's back and shoulders surge with power, and the careful
definition and interplay of the muscles above the trough of the spine reveal
Danby's impressive knowledge of anatomy. The background, a seemingly
random wash in ochres and umbers, cunningly suggests a great wave curling
away from the diver's body.

Danby began his studies for a gymnast by sketching female gymnasts in
action. He found, however, that for all their style and grace, they did not
convey the thrust and strength he was looking for. He knew that his final
image would have to be of a male gymnast. Nevertheless he made some
splendid studies of female gymnasts, and *Walking the Beam* is one of them. It
shows a young woman walking a beam that is only 10 cm. wide, her arms held
vertically above her head, her right leg extended, her toes flexed and ready to
grip the beam as she takes her next step.

In searching for an ethnic diversity which would contribute to the universality of these images, Danby decided to use a black athlete as a model for *The Sprinter*. His pencil studies of the sprinter crouching on the starting line are marvels of concentrated power. This sprinter is like a dynamo generating energy that aches for release. Danby gives us an athlete in peak physical condition, his deltoids like hillocks, his distended veins like an intricate web of steel cables binding his forearms and wrists, his thighs thick with slabs of muscle.

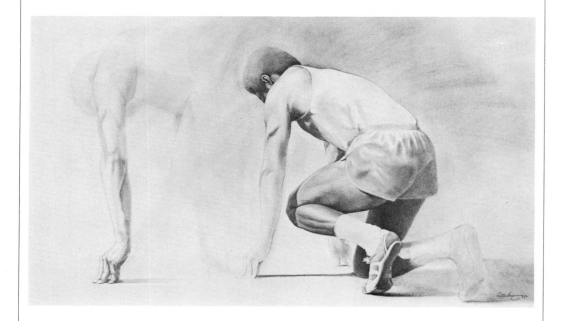

Study of Sprinter, Pencil, 13 1/2" x 21 1/2", 1975, Private Collection.

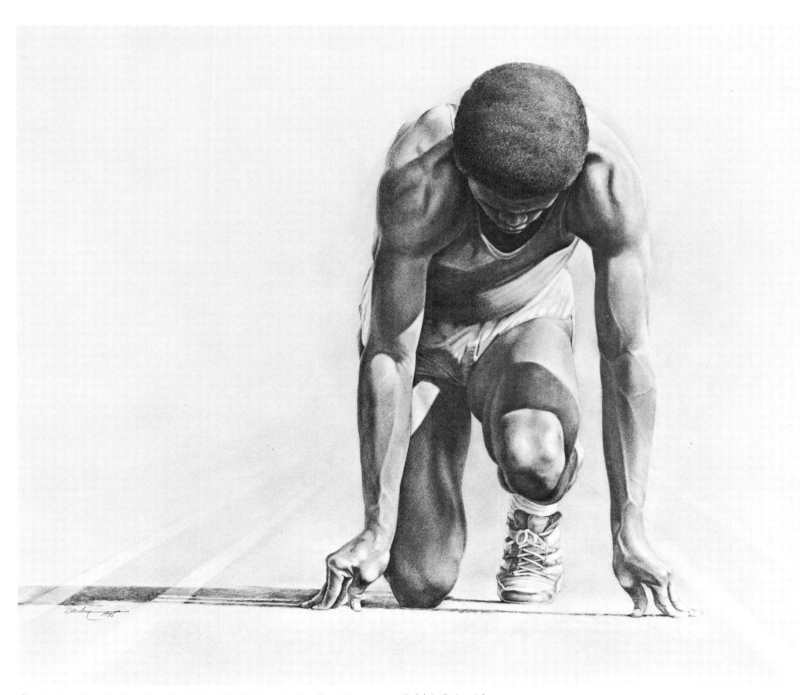

Setting Up, Pencil, 20 1/2" x 25 3/8", 1975. Private Collection, Vancouver, British Columbia.

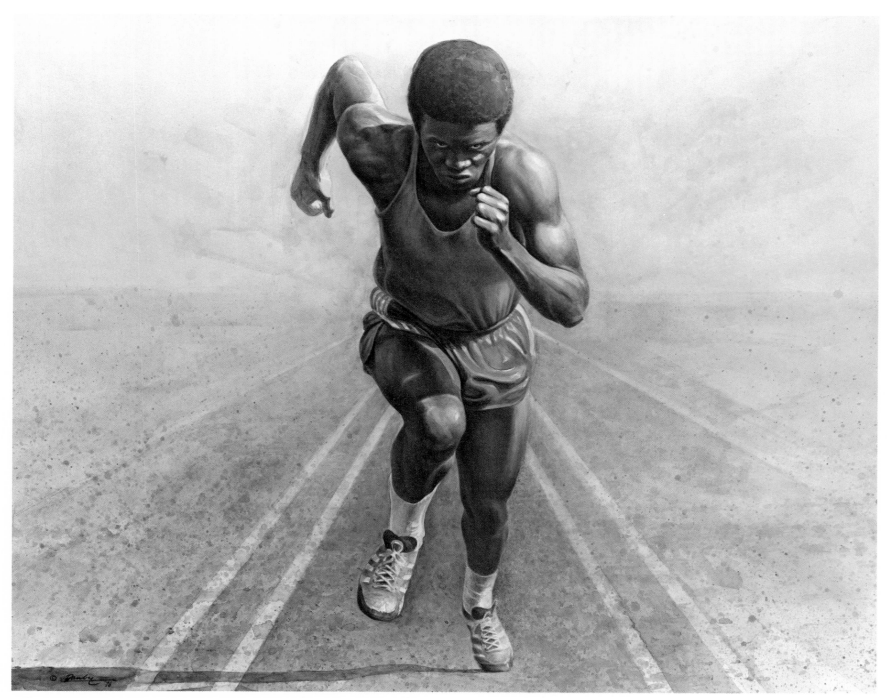

The Sprinter, Watercolour, 21" x 26 1/2", 1976, Copyright 1978 National Sport and Recreation Centre.

The Sprinter

In the final watercolour Danby confronts the sprinter head on as he explodes off the blocks at the start of a race. Head lowered, he charges at the viewer like an unstoppable bull, his eyes seeming to see through and beyond the viewer, as if fixed on the tape at the finishing line. His only thought is to be the first to break that tape, to leave the rest of the runners behind as he devours the track which lies between him and his goal. Danby uses a spatter technique which gives the impression of dirt hurtling beneath the sprinter's flying feet.

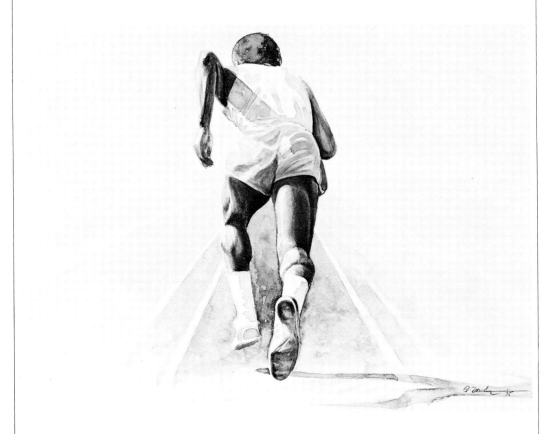

Rear Study of Sprinter, Watercolour, 10 1/2" x 13 1/2", 1975, Private Collection.

Danby's instinct for the pose which makes for the most drama is unerring. *Full Stride* is a fine watercolour study of a sprinter striding like a gazelle, his arms pumping, his thighs and calves stretched and straining for speed. But this side view is the commonest one for depicting a sprinter in action, and Danby discarded it as a visual cliché. He was just as ruthless with his watercolour studies of an Oriental male gymnast, rejecting pictures which lesser artists would have been proud to offer as ultimate images.

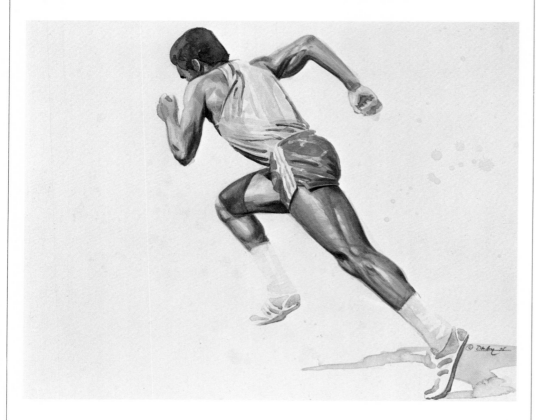

Full Stride , Watercolour, 10 1/2" x 13 1/2", 1975, Private Collection.

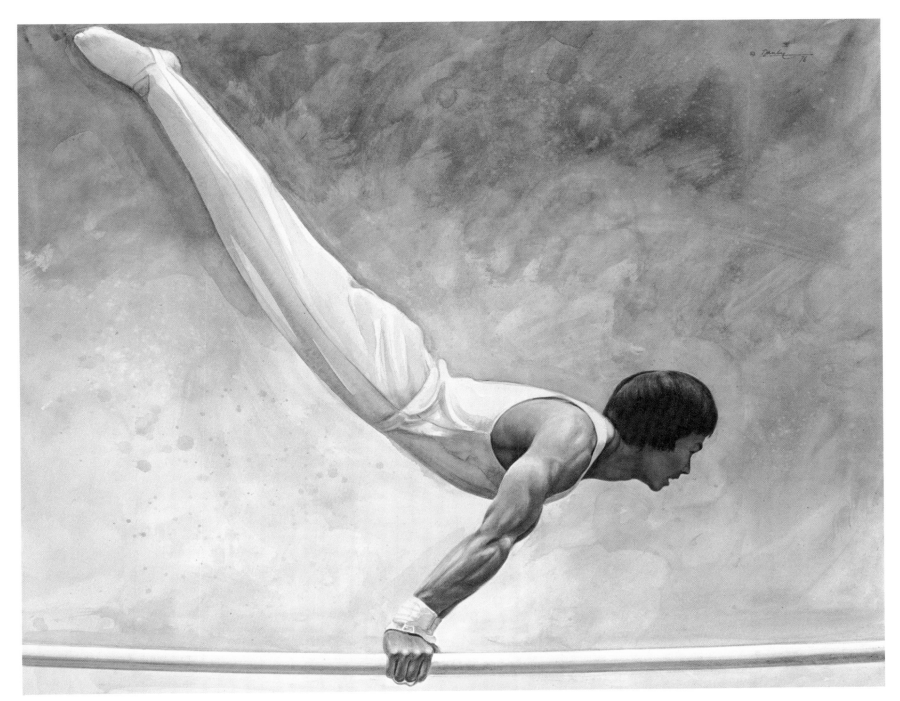

The Gymnast, Watercolour, 21" x 26 1/2", 1976, Copyright 1978 National Sport and Recreation Centre.

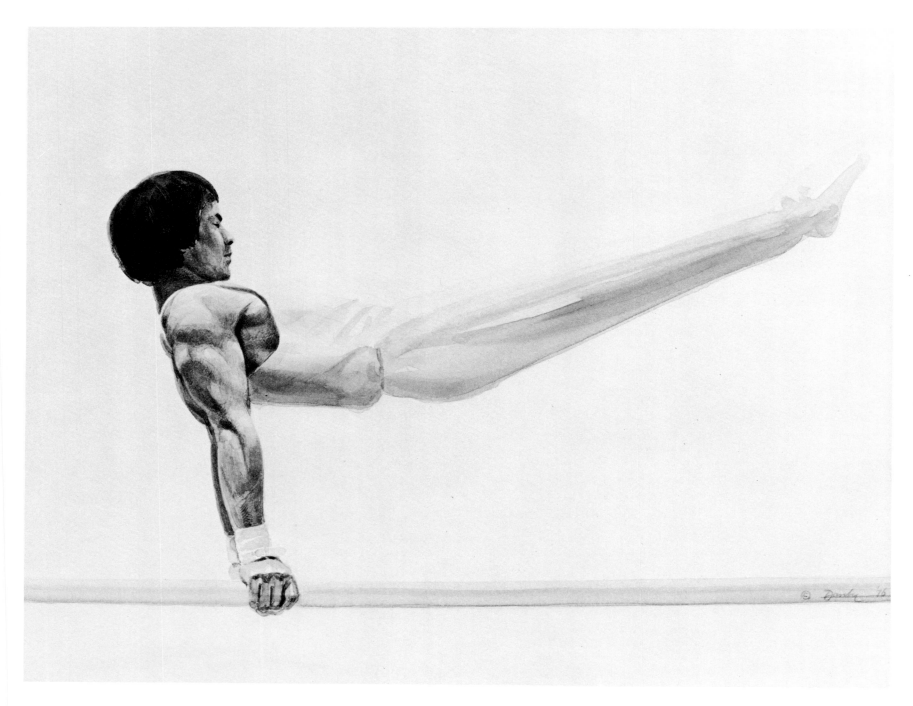

Study for The Gymnast, Watercolour, 10 1/2" x 13 1/2", 1976, Private Collection.

The Gymnast

For his final watercolour of *The Gymnast*, Danby selected a pose from one of the most difficult exercises on the parallel bars. He showed his gymnast with his body suspended diagonally above the bars, its entire weight supported by the arms. The fantastic strain on the arms is brilliantly suggested by the lighting, which emphasizes the rigidity of the forearm muscles and tendons, which rise from the strapped wrists like a closely woven bundle of steel rods. The lines of the sinewy arms are followed deftly as they flow through the hard curve of the triceps and the corrugated muscle of the deltoid. It is a monumental figure which could be carved in bronze.

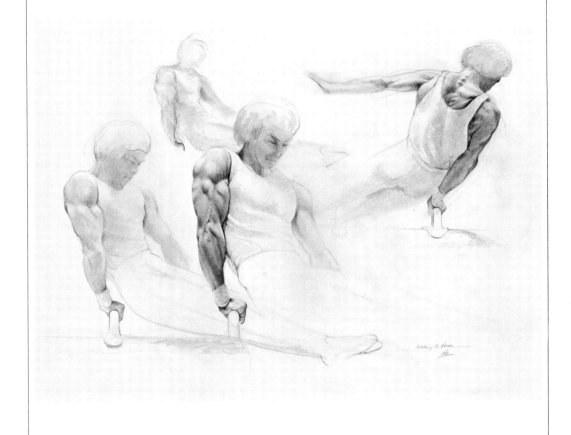

Working the Horse, Pencil, 17 1/2" x 22 3/4", 1975-76, Private Collection.

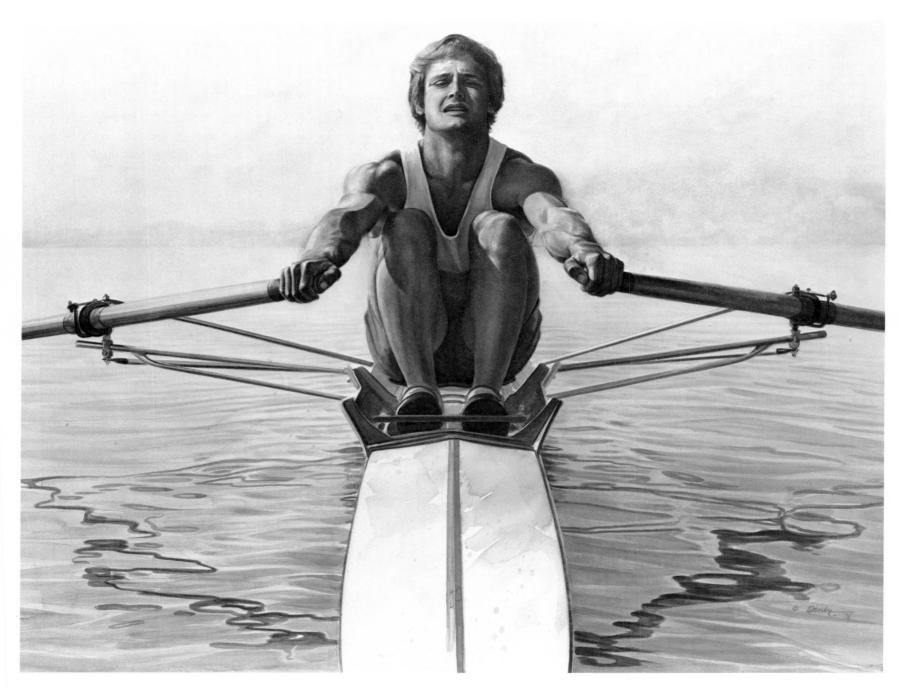

The Sculler, Watercolour, 21" x 26 1/2", 1976 , Copyright 1978 National Sport and Recreation Centre.

The Sculler

The Sculler is a study of enormous strength and determination. As he did with the sprinter, Danby immediately engages the viewer's interest by bringing him face to face with an athlete in the throes of tremendous physical exertion. The sculler grimaces with the huge effort of pulling on the oars. The scarlet line in the centre of the scull leads the eye straight to the sculler (where the scarlet is repeated in the colour of his shorts); it then travels along the steel struts of the oars, back along the oars themselves, to the magnificently muscled arms of the sculler. From the sculler's head the eye travels back again along the arms, oars and struts, until it is back to that scarlet line which bisects the bow of the scull. The water is silken, the oars reflected in a dark scribble across its gentle blue ripples.

Danby was concerned that his picture should contain no echo of Thomas Eakins's great series of sculling pictures. This is one of the reasons he rejected a study he made of the back view of a sculler, with the scull shown from the side. Not only was this too passive, with none of the drama of a direct frontal view, but it inevitably invited comparisons with Eakins's sculling studies and perspective drawings.

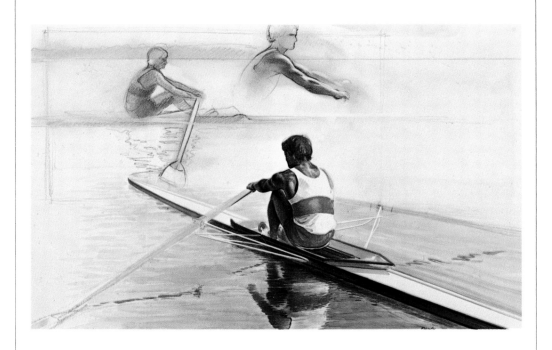

Study for The Sculler, Watercolour and Pencil, 13" x 21 1/2", 1975 , Private Collection.

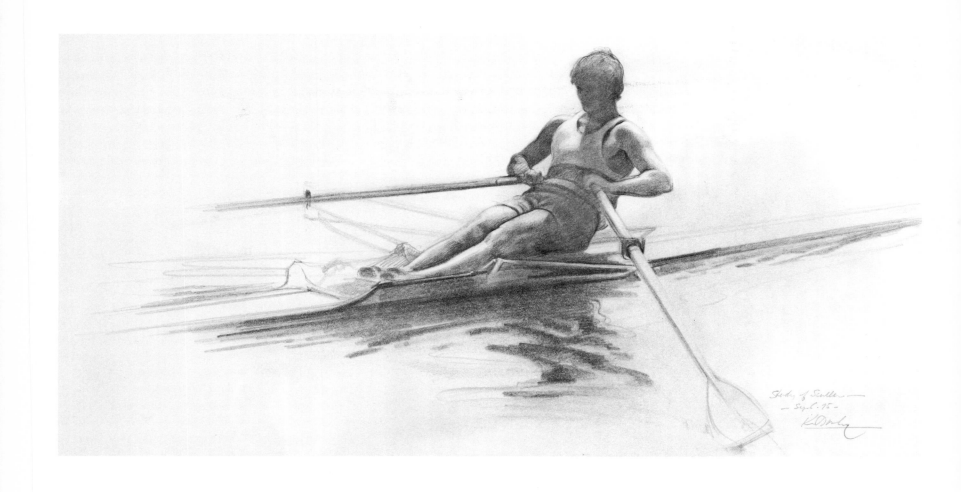

End of the Stroke, Pencil, 9" x 18 3/4", 1975-76, Private Collection.

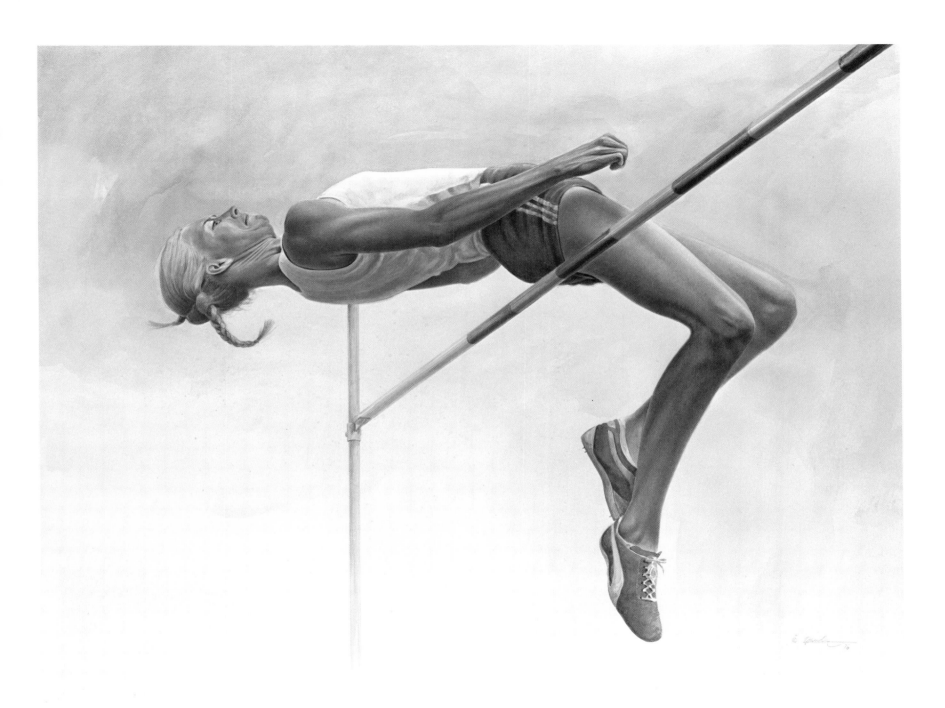

The High Jumper, Watercolour, 21" x 26½", 1976, Copyright 1978, National Sport and Recreation Centre.

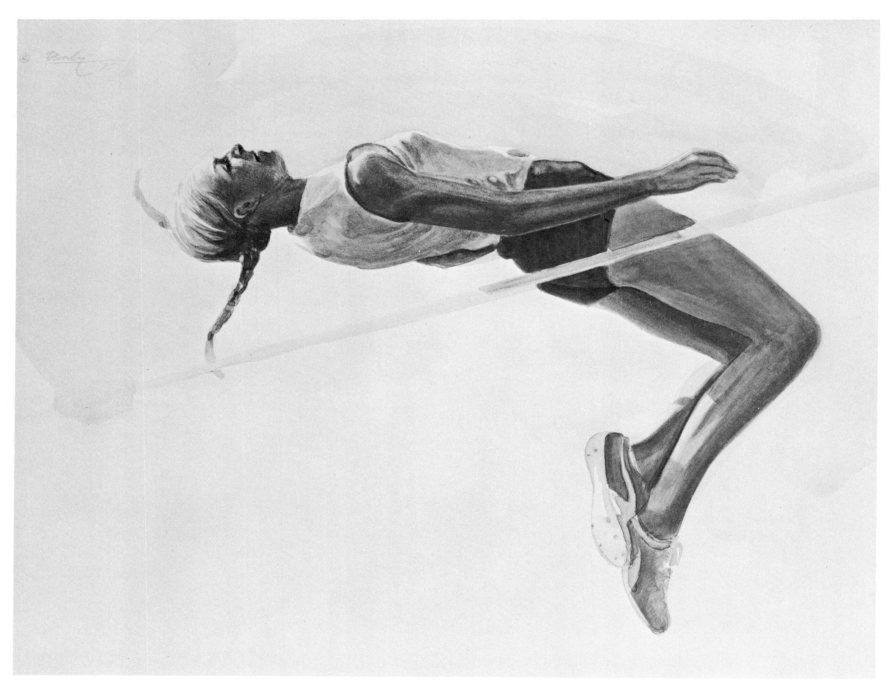

Study for The High Jumper, Watercolour, 10½" x 13½", 1976, Private Collection.

The High Jumper

The *High Jumper* is stopped in midair as she arches backwards over the bar. Her neck muscles are pleated as she tucks in her chin; her lean, lithe body lies suspended over the undisturbed crossbar before sailing over in a successful jump. Danby sketched this high jumper at the Pan American Games in Mexico City. He was looking for a model who would express "bounce and elegance", as well as the drama of the single, fleeting act of an athlete catapulting herself over a bar. All these qualities are embodied in his high jumper, along with a playful, whimsical touch: the twirl of her small blonde braids as she strives to clear the bar.

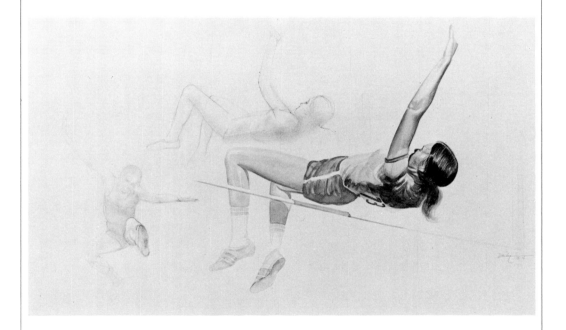

Over the Bar, Watercolour and Pencil, 13 1/2" x 21 1/2", 1976, Private Collection.

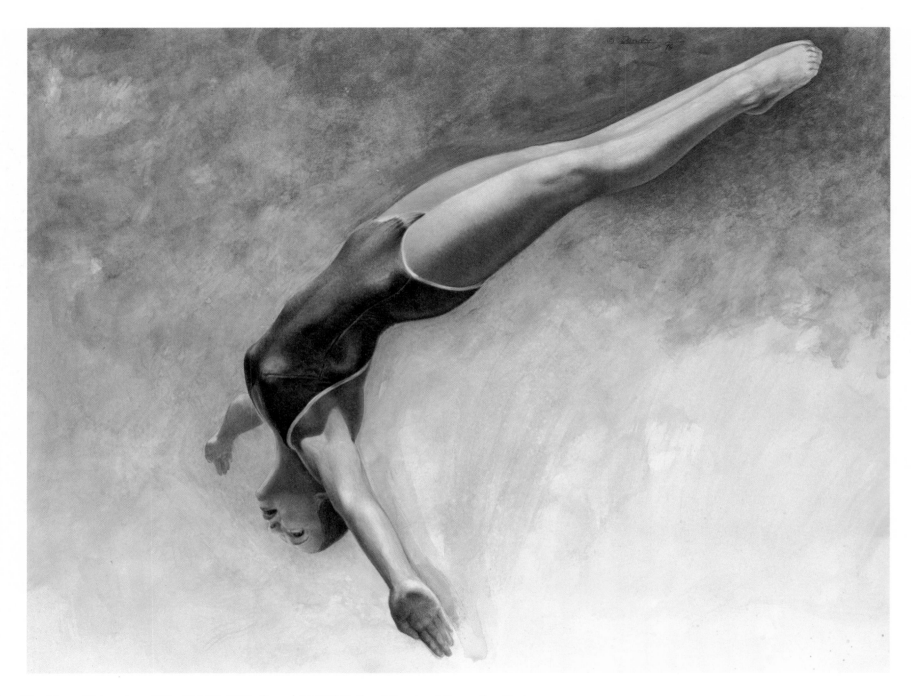

The Diver , Watercolour, 21" x 26 1/2", 1976 , Copyright 1978 National Sport and Recreation Centre.

The Diver

Danby's final watercolour of *The Diver* is a celebration of an athlete's freedom. The diver is shown in the ecstasy of flight, swooping backwards, curved like an archer's tightened bow. Her lips are parted in an exultant smile as she plummets towards the water. Danby's skilful brushwork brings out the sheen of the diver's wet costume, and accentuates the shapes within it — the prominent hip bones, the abdominal muscles, the breasts.

In a pencil study of the diver, Danby tried, and rejected, a side view of the figure, as well as some rapid sketches of the diver's head. Then, in an inspired doodle, he conceived the idea of showing the body from the front, dramatically foreshortened. He made an excellent dry-brush study of this pose, again accentuating the wet shimmer of the costume stretched tightly over the pelvis, the rib cage and the breasts. The arms are spread at right angles, like the wings of a gliding bird. But this image, too, was passed over in favour of the final one of the brilliant backward dive.

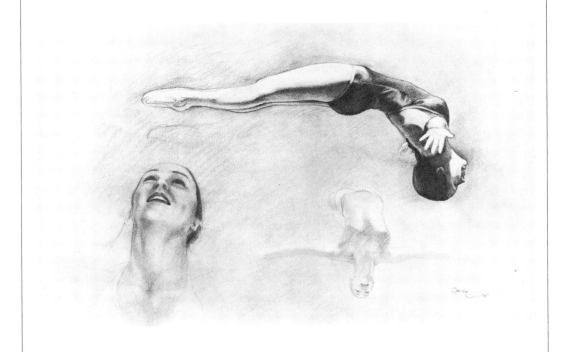

Study for The Diver, Pencil, 13" x 21 1/2", 1975, Private Collection.

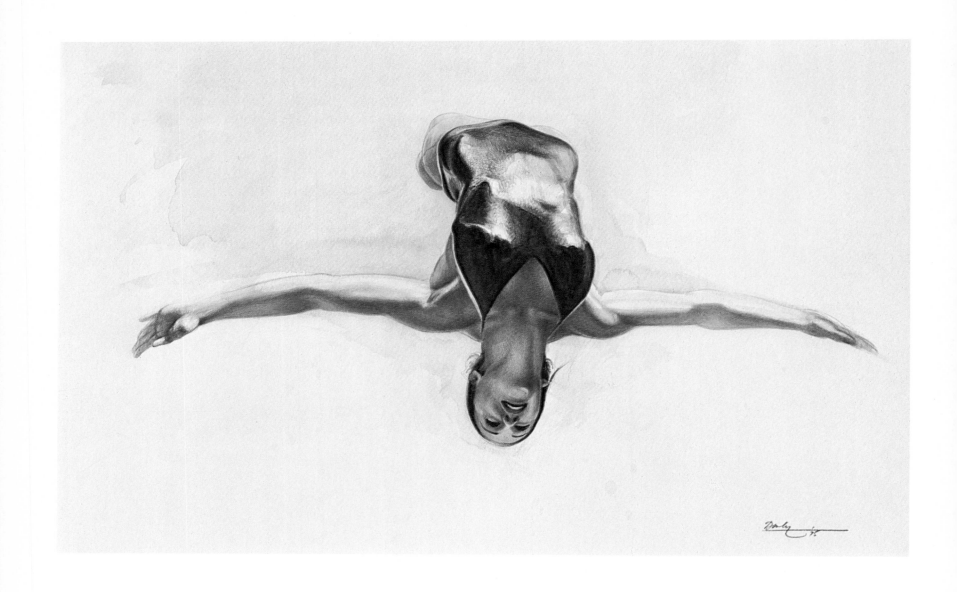

Study for The Diver, Drybrush Watercolour, 13" x 21 1/2", 1975 ,Private Collection.

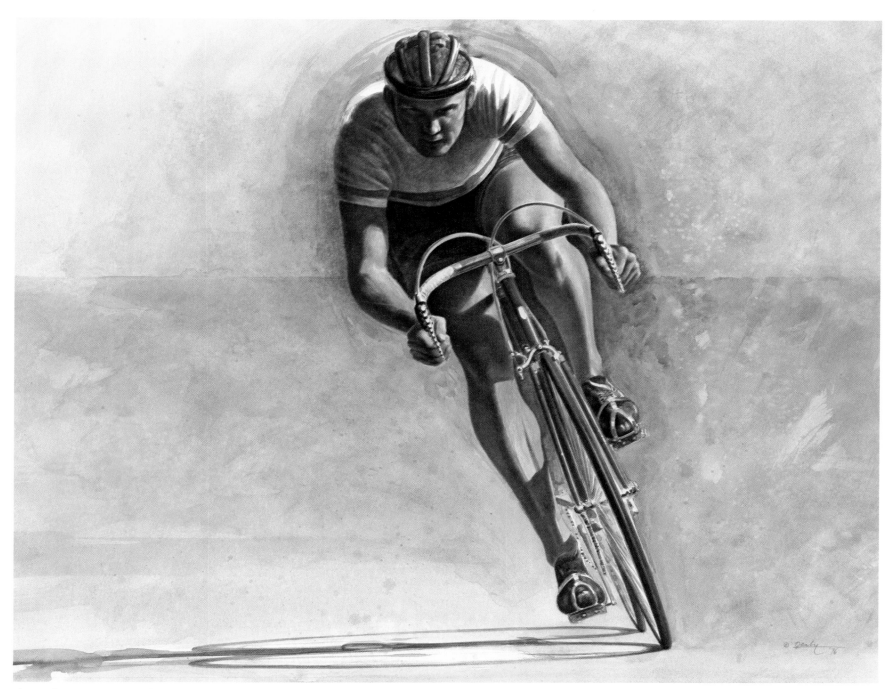

The Cyclist , Watercolour, 21" x 26 1/2", 1976 , Copyright 1978 National Sport and Recreation Centre.

51

The Cyclist

Like the sprinter making his powerful spring, *The Cyclist* rushes straight at the viewer. He is crouched with his helmeted head held low over the dropped handlebars of his racing machine, his massive thighs and huge, rounded calves providing the power to turn the stirruped pedals fast enough to propel the rider at a speed of around 50 m.p.h.

In his dry-brush study for *The Cyclist,* Danby portrayed the rider in profile, showing the curve of his back, and the straining muscles of his powerful legs. The bicycle is suggested in a ghostly outline which hints at the stripped-down lightness of the machines used for competition racing. The background is a gradated wash of ochres and umbers, with touches of blue. The colours are applied in swirls which suggest the turbulence of the air currents around the cyclist as he moves at high speed, participating in one of the world's most gruelling — and popular — sports.

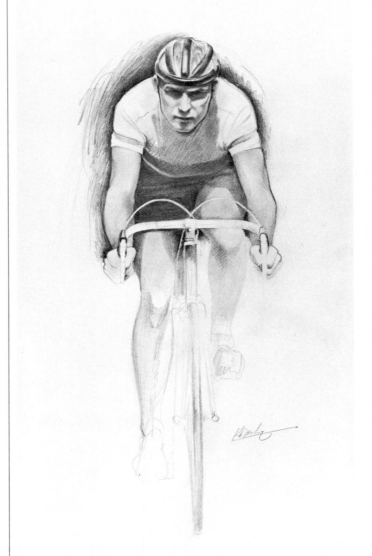

Study for The Cyclist, Pencil, 9½ x 16" 1975, Private Collection.

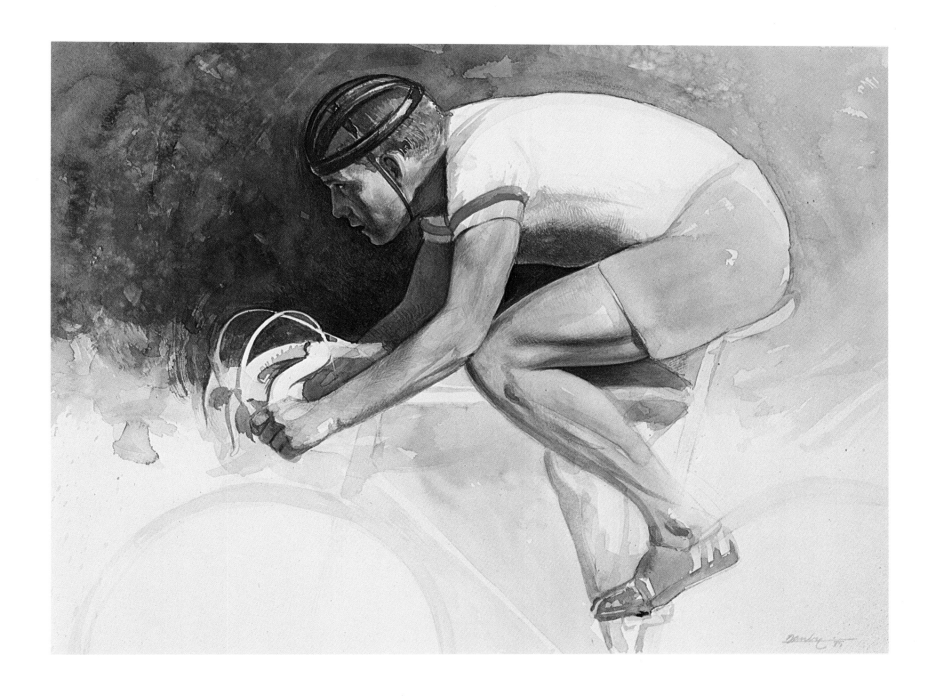

Study for The Cylist, Watercolour, 21" x 27", 1975 ,Private Collection.

The creation of these images took many months of intense labour. When Danby is engaged on a major project, he goes into seclusion in his studio, as a monk goes into a religious retreat. He works there for an average of 15 hours a day, and sleeps on a cot in the studio. But when the six watercolours were completed, Danby found that his tireless imagination had not yet finished with the theme of Olympic athletes.

He now visualized a set of four black and white lithographs of individual athletes, and, as he had done in the watercolours, he sought to portray each of them at the climactic moment of their particular sport. Danby determined that these subjects could best be rendered in serigraphy, with the addition of selected colour.

 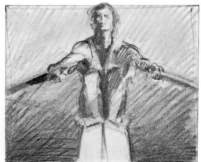 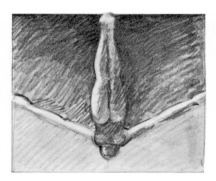 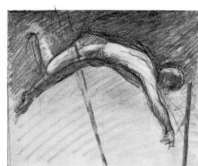

Preliminary pencil sketches for the Olympic Serigraphs, 1976; 23" x 6¼", Private Collection.

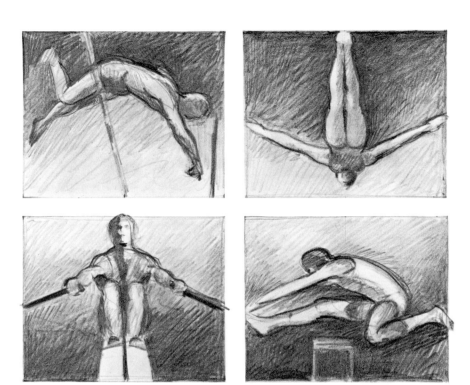

Preliminary pencil sketches for the Olympic Serigraphs, 1976;
11 x 14" Private Collection.

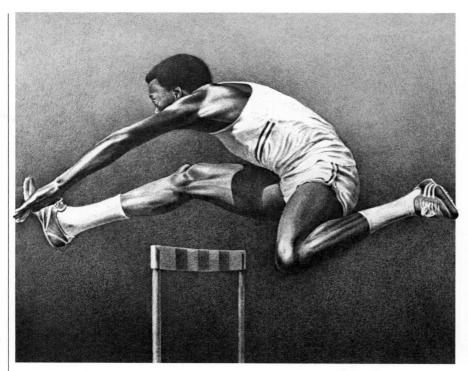 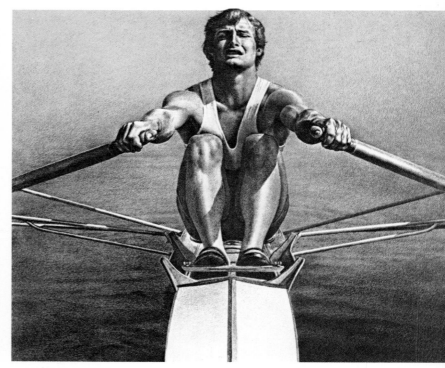

The Hurdler *The Sculler*

Olympic Serigraphs, A portfolio of four, five colour serigraphs, 16" x 18", Edition of 150, 1976.

The set of four 5-colour serigraphs is one of Danby's most carefully
planned works. The design has a fluency which ensures a deliberate interaction
between the images: it is a series of interlocking diagonals and verticals,
described by the limbs and equipment of the athletes. In the first image, the eye
is led from the diagonal of the hurdler's extended arm and leg along the slope
of his back, down to the thigh, and up again along the diagonal of his trailing
leg. The eye is then led into the diagonal formed by the sculler's oar, pauses
along the vertical axis of the sculler's body and the scull, and then follows the
second oar out of the picture. The diver's arm becomes an extension of the oar
as a diagonal once again meets a vertical axis — the diver's body — before
rising again along the diagonal of the right arm. The continuity remains

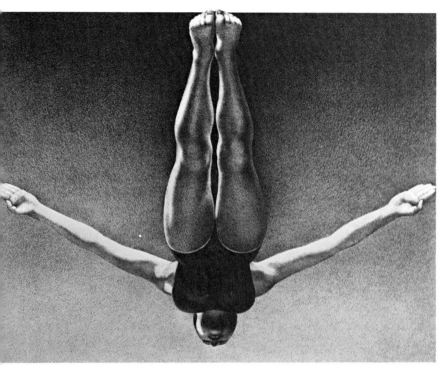

The Diver

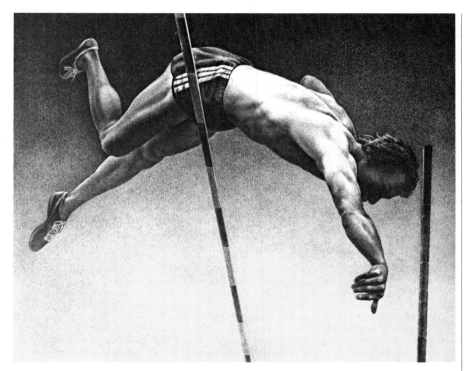

The Vaulter

unbroken as the pole vaulter's left leg forms a diagonal which leads the eye to his pelvis, where the vertical axis is supplied by the cross bar. Once again the eye travels downwards along the vaulter's sloping body, and along his extended right arm, where it is finally stopped by a second vertical line formed by the vaulter's pole.

The orchestration of the colour is as subtle as the seamless geometry of the figures. Warm colours are placed at each end of the group, and cooler colours are contained within. In *The Hurdler* and *The Sculler,* the colour accents occur at the top of the picture; in *The Diver* and *The Vaulter,* the colour accents are at the bottom.

There is no loss of harmony if, instead of being displayed in a horizontal sequence, the serigraphs are arranged as a square, with *The Vaulter* and *The Diver* next to each other, and *The Sculler* and *The Hurdler* placed directly below.

In this alternate grouping, the movements of *The Vaulter* and *The Hurdler* flow inwardly. The overall design is balanced by the symmetry of *The Sculler* and *The Diver,* both of which have an arrowhead composition (which points downward in the image of *The Diver,* and upward in the image of *The Sculler*). The directional flow of *The Sculler* and *The Diver* is distinctly opposite to that of *The Vaulter* and *The Hurdler.*

Images of water and land sports are placed diagonally opposite each other; and so are the warm and the cool colours. The dark tonal borders are situated across both the top and the bottom of the group which then allows all four colours to interact at the centre.

In spite of the length of time it takes Danby to finish a painting or a serigraph, his output has been prodigious, because of his unremitting industry. At 38, he has completed more than 151 egg tempera paintings, 296 watercolours, dry-brush drawings and studies, 100 pencil drawings, 15 editions of multicolour serigraphs (excluding the portfolio of Olympic athletes), and 14 editions of lithographs.

This substantial and distinguished body of work has brought Ken Danby to the front rank of Canadian art, and has won him an international reputation as a modern master of realist painting. Canadian art critics, however, have been reluctant to acknowledge Danby's genius. In the early 70's, when he was already producing masterpieces, Toronto critics (with the exception of Paul Duval) nearly trampled each other in the rush to enshrine in print their incapacities and pygmy prejudices. Critics on the west coast were more perceptive, and in Vancouver Arthur Perry recently called Danby "the most accomplished realist in Canadian art". His opinion was endorsed by British critic Michael Shepherd who, in the November 1977 issue of *Arts Review*, referred to Danby as "a less sentimental artist, and a finer draughtsman, than Andrew Wyeth, yet who is seldom talked about in 'art' circles, although through and through 'Canadian'." Small wonder that Brian Stock, writing in the *Times Literary Supplement* (May 14, 1976), stated flatly that "The internal standards for judging Canadian works of literature and art are not widely respected outside the country."

Danby's self-sufficiency has not fully immunized him from the scurrilous attacks of arrogant and worthless critics. When he speaks of his detractors his grey-blue-green eyes darken as if a cloud has passed over sunlit water. But he is philosophical about them: "Critical attacks are a minor irritation, a thorn you pull out and throw away." He is content to leave the judgment of his work to history, serenely confident in its value and its permanence. "Integrity will always survive. Maybe it's overshadowed at times, but it will surface, and continue to surface. Deadwood will sink; and if it deserves to float, then it'll float. It just takes the filtering of time, and the action of the tides of history, to see what floats and what sinks."

Danby has never regarded sports and art as being mutually exclusive, and for proof he points to work of Eakins, Bellows, McKenzie and a host of other artists. Danby rightly sees himself as the inheritor of a great tradition which began with the Greeks and their celebration of sports in art. He has little patience with the macho sportsman who derides art as something unmanly; and he is equally incensed by artists who are contemptuous of athletes, as if they were merely muscle-bound neanderthals. As a corrective to both these attitudes, Danby has made sports the subject of some of his major paintings. But it is important to remember that the range of his art is not narrow, and his sports paintings represent only a part of his total output.

Danby would like to see art given a high and honoured place in society: "To relegate art to the role of simply being decoration, or an elitist activity, or a hobbyist pursuit, or an intellectual exercise, is regressive and stupid. Art is essential in order for a society to regard itself as enlightened."

He insists that art should be introduced as a major subject in schools, since he considers it a powerful educative force. "I believe the role of the artist can be related to that of the teacher: *a teacher of seeing.* Every person who is capable of sight deserves to have this faculty expanded, as part of the process of enlightenment." As an artist, Danby, like William Blake, sees *through,* not *with*, the eye, and as a result he makes visible what is hidden to ordinary eyes. And by celebrating the commonplace he invests it with immortality, and gives permanence to the fleeting and the ephemeral. He does not make political statements in his paintings, nor does he dwell morbidly on human suffering. His images are direct, pure and complete — a quarantine of truth.

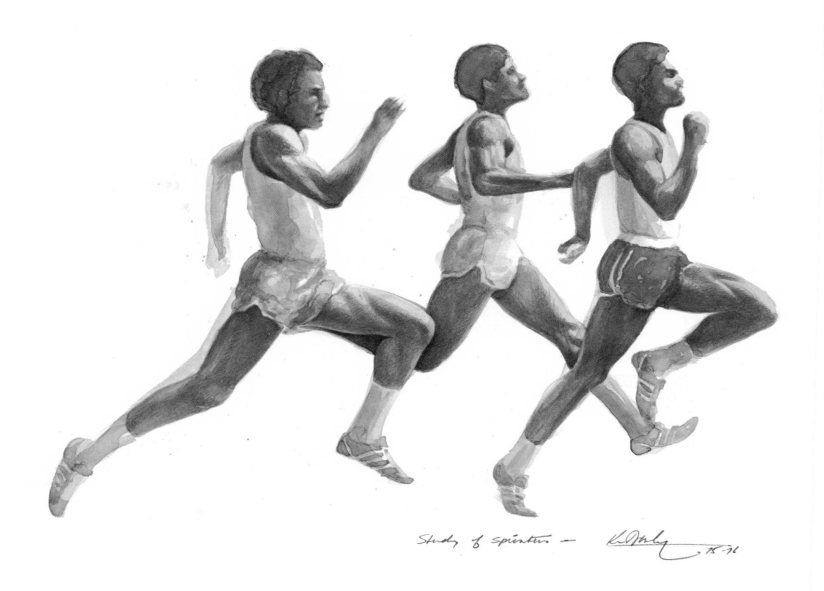

Study of Sprinters, Drybrush watercolour, 14" x 11", 1975-1976. **Private Collection.**

"The intellect of man is forced to choose/Perfection of the life, or of the work," wrote W. B. Yeats. Danby has chosen perfection of the work, and he pursues it with the tenacity and ruthlessness of genius. He has unusual reserves of body and mind to draw upon, but his unsparing work schedule has taken its toll. His temples are prematurely flecked with grey, and his eyes are fretted with lines of fatigue. There is a high price to be paid in human terms for the creation of art, and Danby worries about the strain his work imposes on his wife Judy and their three young sons. But she and the family cope splendidly.

There is a special dignity attached to Ken Danby, and it grows out of a sense of achievement. He is a man who is fully conscious of his worth. He is candid about this: "I'm pleased with what I have accomplished so far, but there is always room for improvement. I do feel a sense of achievement, for two reasons: I have set up a form of communication with people, and that is very gratifying. Any performer — and an artist is a performer — needs an audience, as a stimulus and as an incentive. Secondly, having resolved, investigated, explored and taught myself, I have uncovered so much to be done — the opening of the doors to what's ahead of me. There's a great satisfaction in knowing that there's a huge area still to be explored, knowing how to approach it, knowing how to get there."

And so he works alone in his studio, exploring that huge area which still lies undiscovered. His sleepless imagination teems with ideas, and by some mysterious and magical process they are transmuted into brilliant images on paper or gessoed tempera panels. The chemistry of creation defies analysis. All we can say with certainty is that art is a promethean endeavour, with the outlaw imagination raiding heaven to bring fire and light where before there was only darkness.

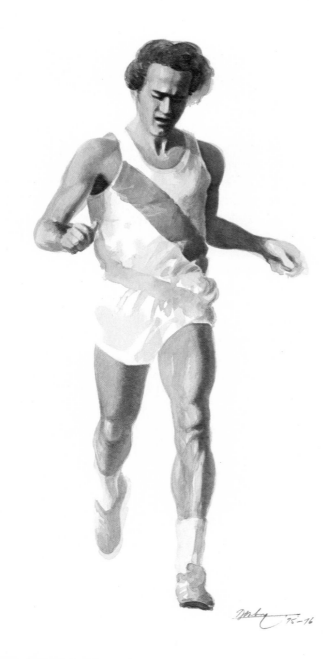

At the Finish, Drybrush Watercolour, 13 3/4" x 11", 1976, Private Collection.

Index

Production
Drewmark Graphics

Design
William Soles Associates

Typesetting
Type-World

Colour Separations
Prolith Incorporated

Film and plates
Strippers World

Printing
Sundance Press

Photography
T. E. Moore, Toronto